FANCY ALPHABETS

FANTASIE-SCHRIFTTYPEN
ALFABETOS ORNAMENTALES
ALPHABETS ORNEMENTAUX
ALFABETI DECORATI
ALFABETOS ORNAMENTAIS

The Pepin Press BV
P.O. Box 10349
1001 EH Amsterdam
The Netherlands

tel +31 20 4202021
fax +31 20 4201152
mail@pepinpress.com
www.pepinpress.com

concept & cover design: Pepin van Roojen
layout: Kitty Molenaar

ISBN 978 90 5768 062 5

10 9 8 7 6 5 4 3
2012 11 10 09 08

Manufactured in Singapore

FANCY ALPHABETS

FANTASIE-SCHRIFTTYPEN
ALFABETOS ORNAMENTALES
ALPHABETS ORNEMENTAUX
ALFABETI DECORATI
ALFABETOS ORNAMENTAIS

THE PEPIN PRESS | AGILE RABBIT EDITIONS

THE PEPIN PRESS | AGILE RABBIT EDITIONS

Please visit www.pepinpress.com for more information.

contents

English

Beautifully turned letters came into being long before the invention of printing, and the exquisite letters used in old, hand-written books still serve as models for present-day ornamental type. Lavishly ornamented initials are relics from the times when such letters were intricately painted. Later, initials were carved in wood blocks, and, with the advent of more advanced typesetting, cast in lead or zinc.

The use of fancy initials was the main way of enhancing texts and provided typographers with an opportunity to break the monotony of regular body text. Apart from being pleasing to the eye, initials provide a form of emphasis to focus attention to the beginning of a chapter or paragraph and make text easier to read. In addition, before abstract logos became popular, ornamental lettering would often be used as trademarks.

In **Fancy Alphabets**, hundreds of examples are given, from hand-drawn lettering dating from the Middle Ages to early 20th century styles. All these alphabets are recorded on the accompanying free CD-ROM, indexed by the page on which they appear in this book. Please note that they are saved as image files, and must be imported in the same way as pictures.

Copyright and permission to use: This book contains images for use as a graphic resource or simply for inspiration. The illustrations are stored on the enclosed CD-ROM and can be imported directly into most design, image-manipulation, illustration, word-processing and e-mail programs. The CD-ROM comes free of charge with this book and is not sold separately.

All rights are reserved. However, the files contained on the CD-ROM may be used for private use as long as they are not disseminated, published, or sold in any way or form. For commercial and/or professional use, including any type of printed or digital publication, permission must be obtained from the publishers (see details on page 2). The Pepin Press/Agile Rabbit Editions permission policy is reasonable, and any fees charged tend to be minimal.

Deutsch

Schön geschwungene Buchstaben gibt es schon wesentlich länger als den Buchdruck, und die in alten, handgeschriebenen Büchern verwendeten einzigartigen Buchstaben dienen auch heute noch als Vorlage für ornamentale Zeichen. Die reich verzierten Buchstaben sind Relikte aus einer Zeit, als diese noch aufwändig gemalt wurden. Später wurden die Zeichen in Holzblöcke geschnitzt, und nach der Erfindung des moderneren Buchdrucks wurden sie in Blei oder Zink gegossen.

Durch die Verwendung ausgefallener Zeichen wurden die Texte aufgewertet, und die Typographen durchbrachen damit die Monotonie des Fließtexts. Diese geschwungenen Zeichen sind nicht nur äußerst ansprechend, sondern lenken die Aufmerksamkeit des Lesers auch auf den Beginn eines Kapitels oder Absatzes und machen den Text leichter lesbar. Ornamentale Zeichen wurden häufig auch als Markenzeichen eingesetzt, bevor sich abstrakte Logos durchsetzten.

Das Buch **Fantasie-Schifttypen** enthält Hunderte von Beispielen, von handgemalten Buchstaben aus dem Mittelalter bis zu Varianten des frühen 20. Jahrhunderts. Alle Buchstaben sind auf der beiliegenden kostenlosen CD-ROM enthalten und nach der Seite, auf der sie im vorliegenden Buch abgedruckt sind, indiziert. Beachten Sie bitte, dass die Zeichen als Bilddateien gespeichert sind und wie Bilder importiert werden müssen.

Urheberrecht und Nutzungsbedingungen: Dieses Buch enthält Bilder, die als Ausgangsmaterial für grafische Zwecke oder als Anregung genutzt werden können. Alle Abbildungen sind auf der beiliegenden CD–ROM gespeichert und lassen sich direkt in die meisten Zeichen-, Bildbearbeitungs-, Illustrations-, Textverarbeitungs- und E-Mail-Programme laden, ohne dass zusätzliche Programme installiert werden müssen. Die CD–ROM wird kostenlos mit dem Buch geliefert und ist nicht separat verkäuflich.

Français

Les lettres aux formes élégantes sont apparues bien avant l'invention de l'imprimerie et ces caractères distingués, présents dans les livres anciens manuscrits, servent aujourd'hui encore de modèles pour la typographie décorative. Les initiales somptueusement décorées sont les reliques d'une époque où elles étaient minutieusement peintes. Plus tard, elles furent sculptées dans des blocs de bois puis, avec l'apparition de techniques plus avancées de composition, moulées dans le plomb ou le zinc.

L'utilisation d'initiales ornées était le moyen idéal pour mettre les textes en valeur et permettait aux typographes d'échapper à la monotonie du corps de l'ouvrage. Outre leur aspect esthétique, les initiales mettaient en exergue le début d'un chapitre ou d'un paragraphe et facilitaient ainsi la lecture du texte. De plus, avant le succès des logotypes abstraits, les lettres décorées servaient souvent de marque de fabrique.

Vous trouverez dans **Alphabets ornementaux** des centaines d'exemples, des caractères du Moyen Âge dessinés à la main aux styles propres au xxe siècle. Tous ces alphabets sont disponibles sur le CD-ROM offert avec l'ouvrage et indexés selon la page où ils apparaissent. Enregistrés en tant que fichiers images, ils doivent être importés comme tels.

Droits d'auteur et d'utilisation: Cet ouvrage renferme des illustrations destinées à servir de ressources graphiques ou d'inspiration. Elles sont stockées sur le CD-ROM inclus et peuvent être importées directement dans la plupart des logiciels de conception, de manipulation d'images, d'illustration, de traitement de texte et de courrier électronique. Le CD-ROM est fourni gratuitement avec le livre mais ne peut être vendu séparément.

Tous les droits sont réservés. Cependant, les fichiers du CD-ROM pe t être utilisés à titre privé tant qu'ils ne font pas l'objet d'une diffusion, d'une publication ou d'une vente sous quelque forme que ce soit. Pour les applications de type professionnel et/ou commercial, y compris tout type de publication numérique ou imprimée, il est impératif d'obtenir une autorisation préalable des éditeurs (voir détails en page 2). La politique d'autorisations de Pepin Press/Agile Rabbit Editions reste raisonnable et les droits exigés sont réduits au minimum.

Español

La letra cuidadosamente elaborada empezó a existir mucho tiempo antes de la invención de la imprenta, y la exquisita caligrafía de los manuscritos antiguos todavía sirve de modelo para la tipografía ornamental en la actualidad. Las letras capitulares suntuosamente adornadas son el vestigio de un tiempo en que las letras se dibujaban con preciosismo. Posteriormente, estas iniciales pasaron a tallarse en bloques de madera y, con la evolución de las técnicas de composición tipográfica, a estamparse con moldes de plomo o zinc.

El uso de letras capitulares decorativas era el principal método de embellecimiento de los textos y otorgaba a los tipógrafos la oportunidad de romper la monotonía del texto simple. Además de ser agradables a la vista, dichas letras constituyen una forma de énfasis, ya que dirigen la atención hacia el comienzo de un capítulo o párrafo y así el texto resulta más fácil de leer. Asimismo, antes de la difusión de los logotipos abstractos, la tipografía ornamental se utilizaba con frecuencia como marca comercial.

En **Alfabetos ornamentales** se reúnen cientos de ejemplos, desde caligrafía dibujada a mano que data de la Edad Media hasta estilos de inicios del siglo xx. Todos estos alfabetos se pueden encontrar en el CD-ROM incluido, indexados por la página en que aparecen en el libro. Como son archivos gráficos, deberán importarse del mismo modo que cualquier imagen.

Derechos de autor y permiso de utilización: Este libro contiene imágenes para su uso como recurso gráfico o, simplemente, como fuente de inspiración. Las fotografías están guardadas en el CD-ROM adjunto y pueden importarse directamente desde la mayoría de programas de diseño, manipulación de imágenes, ilustración, procesamiento de textos y correo electrónico. El CD-ROM se incluye de forma gratuita con el libro y no se vende por separado.

Todos los derechos están reservados. Los archivos incluidos en el CD-ROM pueden utilizarse en el ámbito privado siempre que no se difundan, se publiquen o se vendan de ningún modo y en ningún formato. Para aplicaciones de tipo profesional o comercial de los mismos (incluido cualquier tipo de publicación impresa o digital), es necesario obtener la autorización previa de los editores (consulte los detalles en la página 2). La política de permisos de The Pepin Press/Agile Rabbit Editions es razonable y las tarifas impuestas tienden a ser mínimas.

Italiano

I caratteri impreziositi da eleganti ricami compaiono molto prima dell'invenzione della stampa, e le lettere squisite degli antichi libri manoscritti vengono ancora prese a modello dalla stampa decorativa contemporanea. Le iniziali di parola ornate di fregi sono una testimonianza dei tempi in cui tali lettere si dipingevano a mano in modo assai elaborato. Più tardi vengono incise su blocchetti di legno, materiale che, con l'avvento di sistemi tipografici più avanzati, è sostituito dal piombo e dallo zinco.

L'uso di queste fantasiose iniziali era il metodo più utilizzato per aumentare la bellezza del testo, offrendo ai tipografi l'opportunità di rompere la monotonia di una pagina uniforme, e non si tratta solo di caratteri piacevoli da vedere, ma anche di un elemento che richiama l'attenzione e mette in risalto l'inizio di un capitolo o di un paragrafo, facilitando così la lettura. Oltre a ciò, prima della comparsa dei logotipi astratti, le lettere decorative erano spesso usate come simboli commerciali.

In **Alfabeti Decorati**, vengono presentati centinaia di modelli di caratteri, da quelli scritti a mano dell'epoca medioevale agli stili tipici degli inizi del xx secolo. Tutti questi alfabeti si possono trovare anche sul CD-ROM gratuito che accompagna il libro, elencati secondo il numero della pagina in cui compaiono, e in formato file immagine, per cui dovranno essere aperti allo stesso modo delle normali fotografie.

Copyright e licenza d'utilizzo: Il libro contiene immagini da usare come risorsa grafica o solo per ispirazione. Le immagini sono contenute nell'accluso CD-ROM e possono essere importate direttamente nella maggior parte dei programmi per design, elaborazione di immagini, grafica, word-processing e posta elettronica. Il CD-ROM è gratuito e non può essere venduto a parte.

Tutti i diritti sono riservati. È consentito l'uso privato dei file contenuti nel CD-ROM a condizione che non siano distribuiti, pubblicati o venduti in qualunque modo o forma; al contrario, l'uso a scopo commerciale e/o professionale, incluso qualunque tipo di pubblicazione su supporto cartaceo o digitale, è consentito solo previo consenso dell'editore (v. pag. 2). La casa editrice Pepin Press/Agile Rabbit Editions ha adottato una politica ragionevole per la concessione del permesso all'utilizzo del copyright che riduce al minimo il pagamento dei diritti.

Português

As letras adornadas remontam a uma época muito anterior à da invenção da tipografia e ainda hoje os magníficos caracteres usados nos antigos livros manuscritos servem de modelo aos tipos ornamentais. As iniciais sumptuosamente decoradas são relíquias de tempos em que essas letras eram fruto de uma pintura minuciosa. Mais tarde, as iniciais começaram a ser gravadas em blocos de madeira e, com o advento de técnicas de composição tipográfica mais avançadas, passaram a ser moldadas por fundição em chumbo ou zinco.

O uso de iniciais elaboradas era a principal forma de embelezar os textos e permitia aos tipógrafos quebrar a monotonia do corpo de texto normal. Além do prazer visual que proporcionam, as iniciais ornamentadas chamam a atenção para o início de capítulos ou parágrafos e facilitam a leitura do texto. Além disso, antes de os logótipos abstractos se terem generalizado, era frequente o uso de letras ornamentais como marcas registadas.

Em **Alfabetos Ornamentais**, são apresentadas centenas de exemplos, desde caracteres manuscritos que remontam à Idade Média até aos estilos que marcaram o início do século xx. O CD-ROM gratuito que acompanha o livro contém todos estes alfabetos, indexados pelo número da página em que aparecem no livro. Os alfabetos encontram-se gravados sob a forma de ficheiros de imagem e, por isso, têm de ser importados como imagens.

Direitos de autor e autorizações: Este livro contém imagens que podem ser utilizadas como recurso gráfico ou simplesmente como fonte de inspiração. As ilustrações estão armazenadas no CD-ROM anexo e podem ser importadas directamente para a maioria dos programas de desenho, manipulação de imagem, ilustração, processamento de texto e correio electrónico. O CD-ROM é fornecido gratuitamente com o livro, sendo proibido vendê-lo em separado.

Todos os direitos reservados. Porém, os ficheiros contidos no CD-ROM poderão ser utilizados para fins pessoais, desde que não sejam disseminados, publicados ou vendidos. O uso comercial ou profissional dos ficheiros contidos neste CD, incluindo todos os tipos de publicações impressas ou digitais, carece da prévia permissão dos editores (consulte a página 2 para obter informações detalhadas). A política de autorizações de The Pepin Press/Agile Rabbit Editions é muito razoável e as taxas cobradas tendem a ser muito reduzidas.

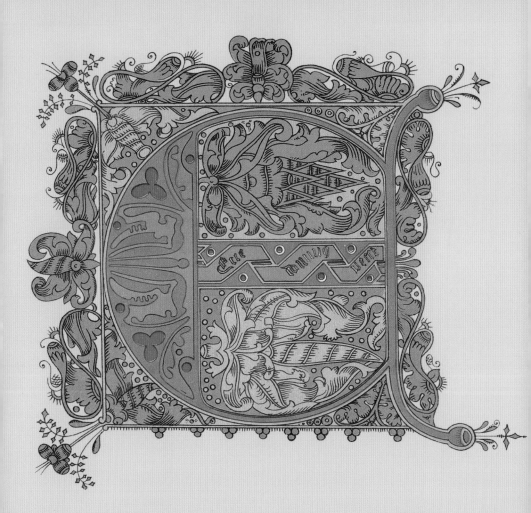

A A B C
D E F G h
J L ꟿ N H
O P ꟼ R S
S S T T U

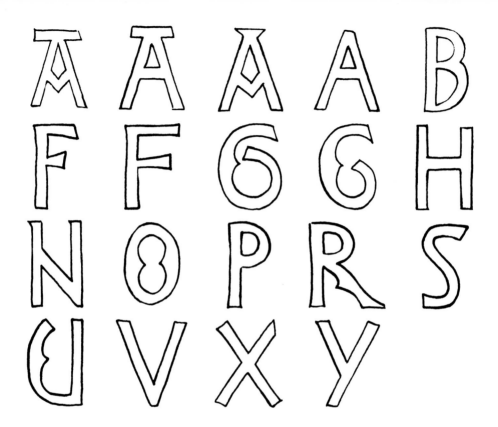

B B D D E E
I L M N N
S S T T U

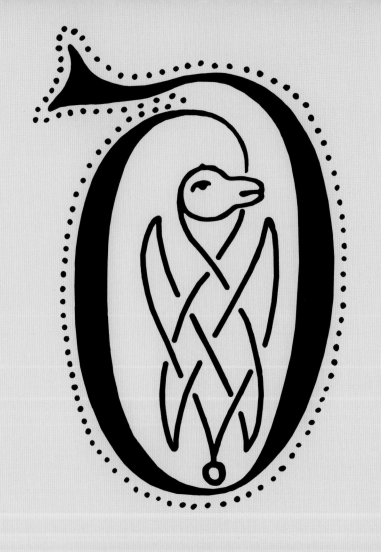

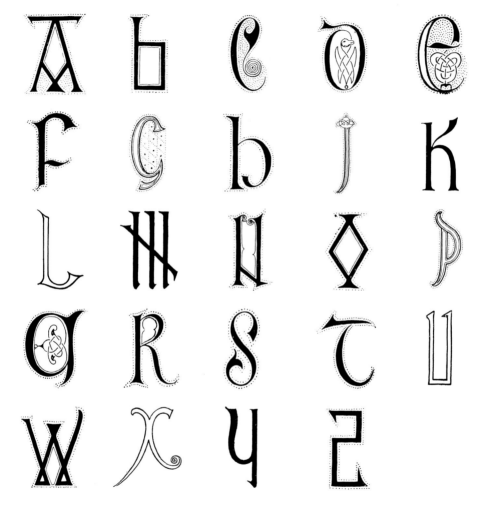

A B C D E
F G h I K
L M N O B
Q R S T U
Y W X Y Z

A B C D E
F G H I K
L M N O P
Q R S T U
V W X Y Z

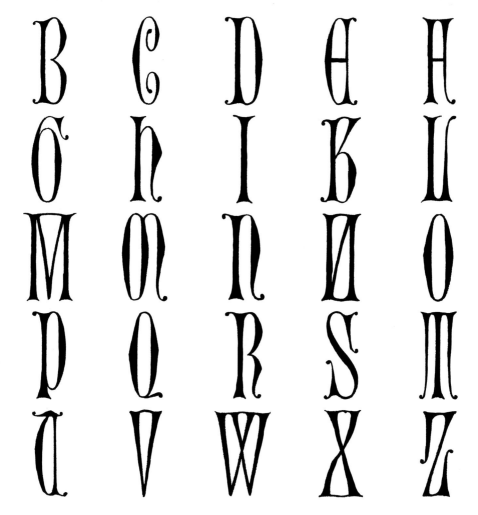

Lombardic, Spain, ca. 1350

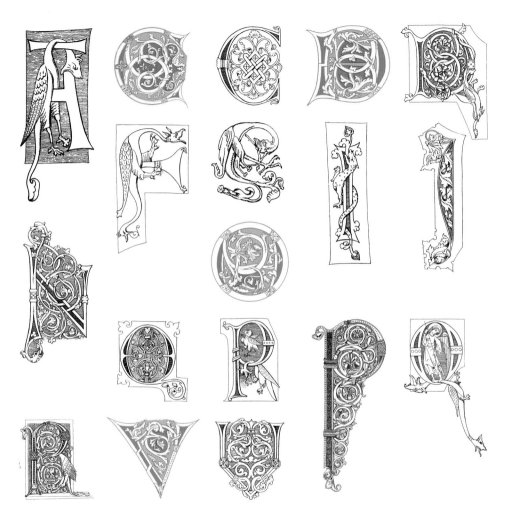

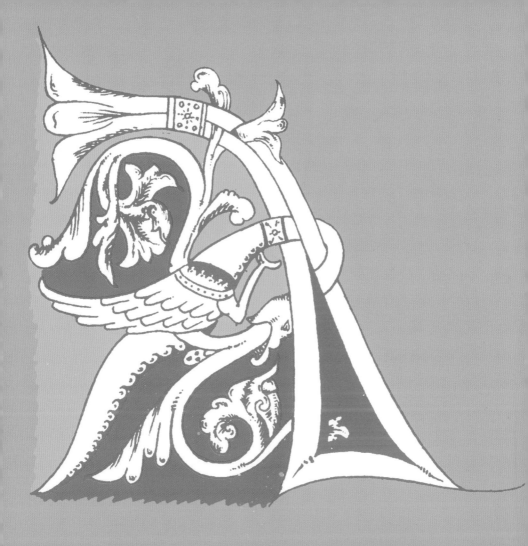

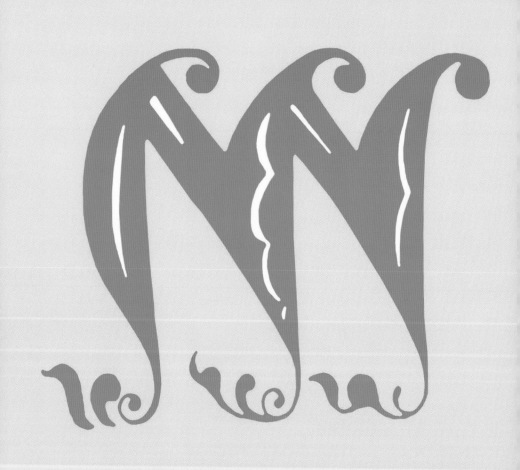

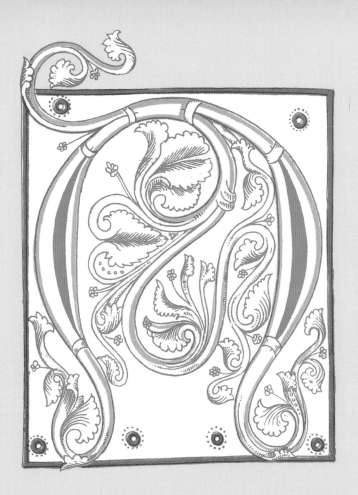

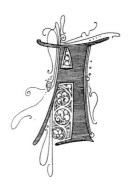

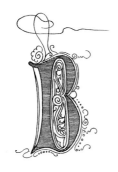

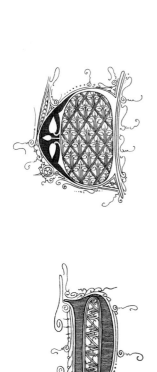

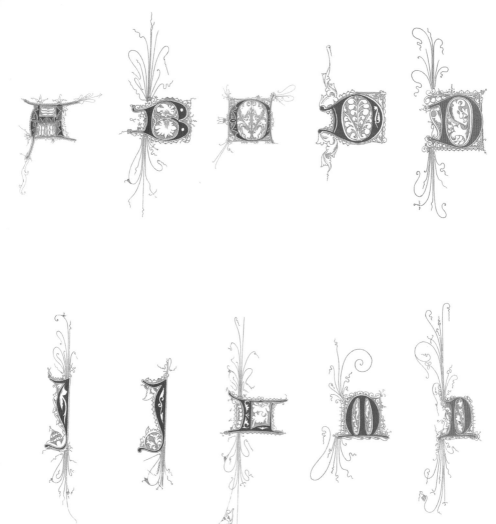

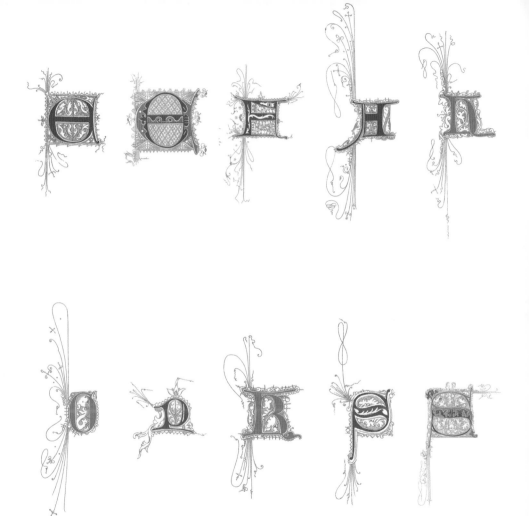

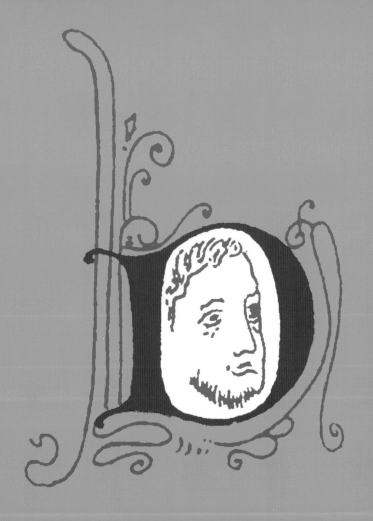

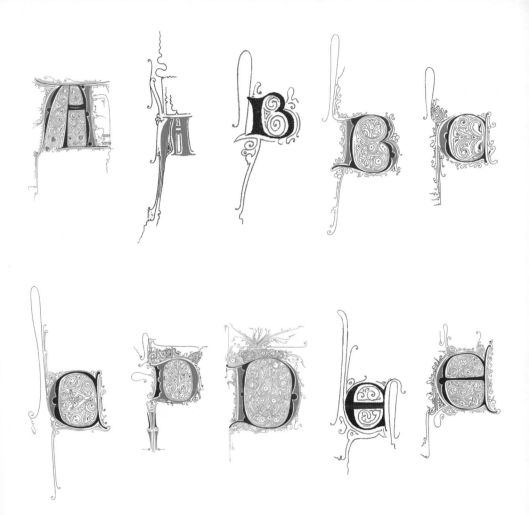

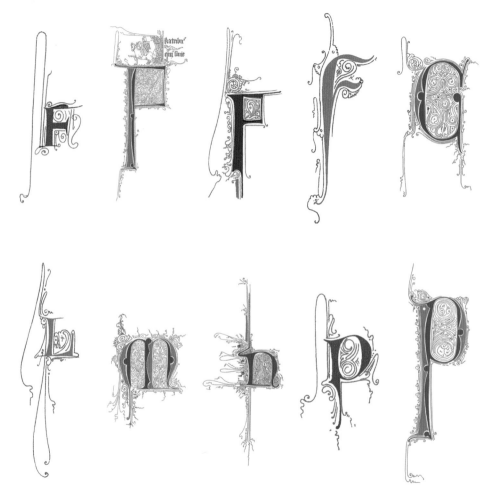

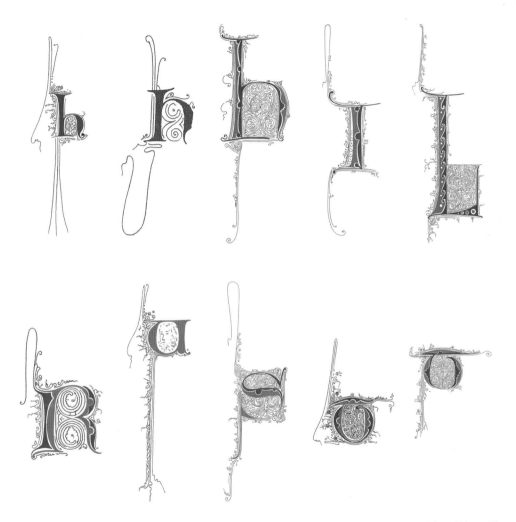

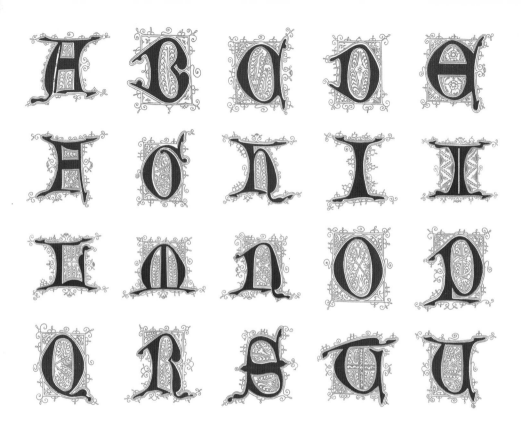

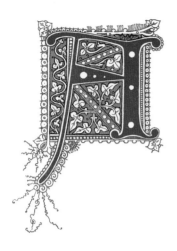

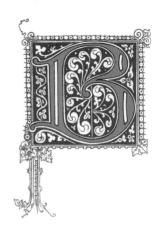

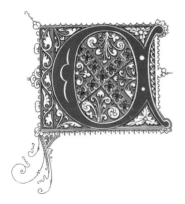

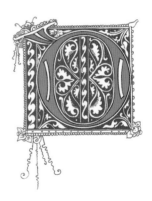

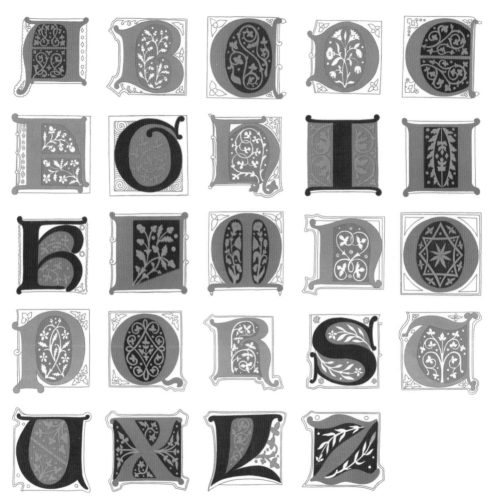

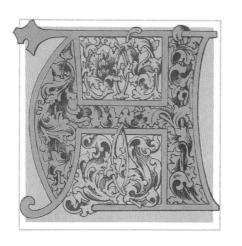

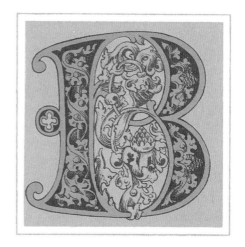

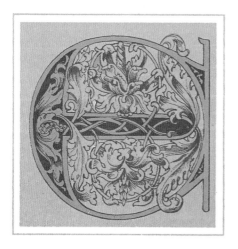

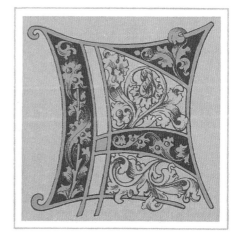

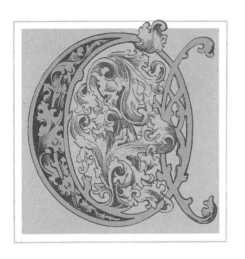

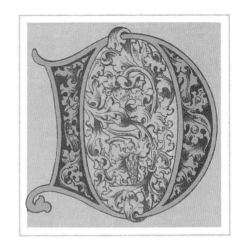

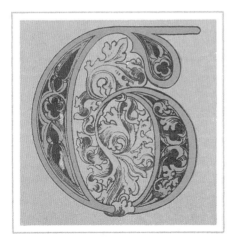

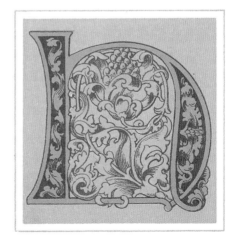

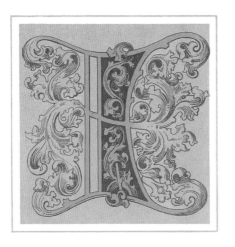

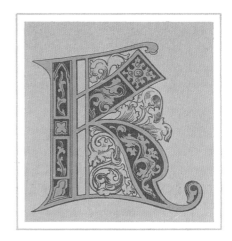

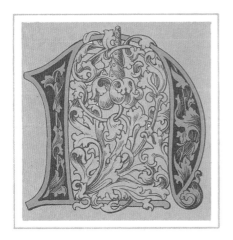

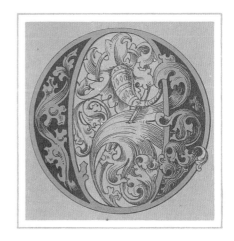

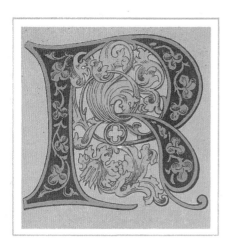

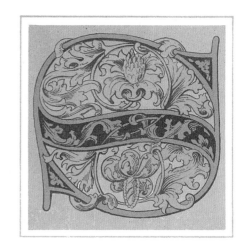

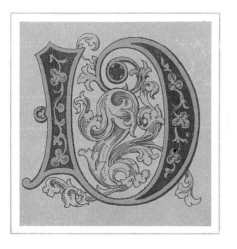

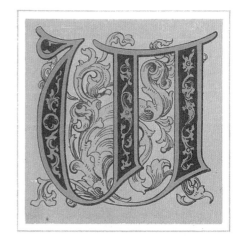

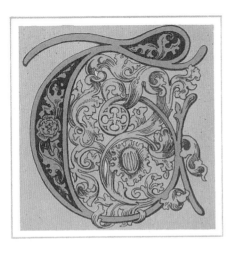

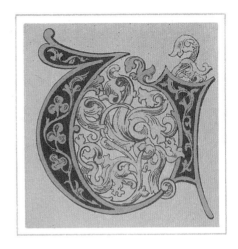

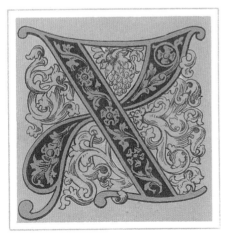

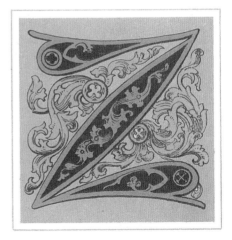

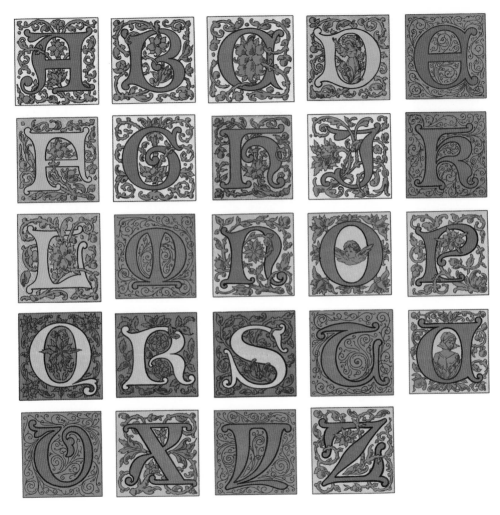

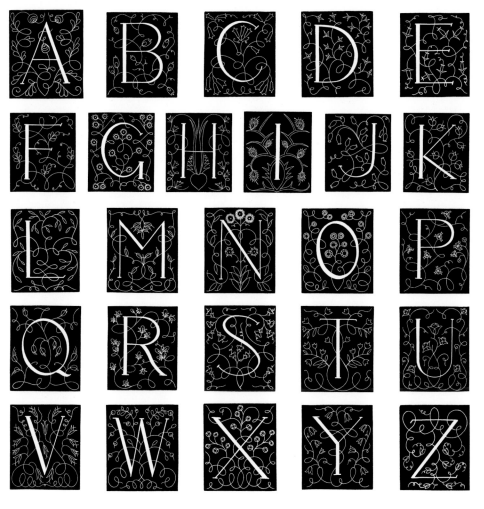

Carl Siegl, Switzerland, ca. 1920 **85**

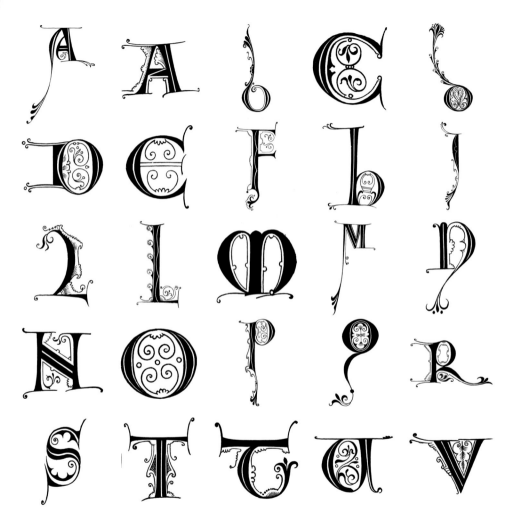

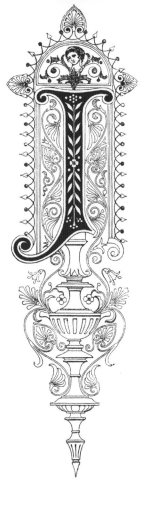

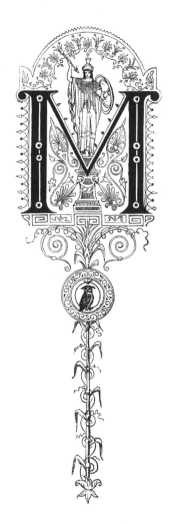

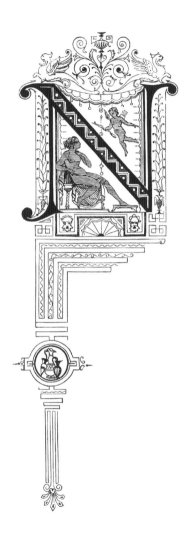

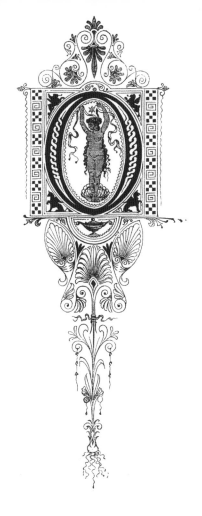

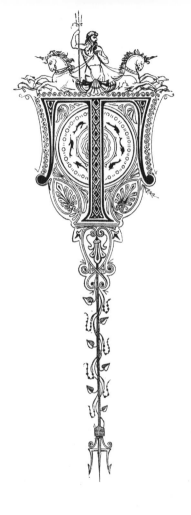

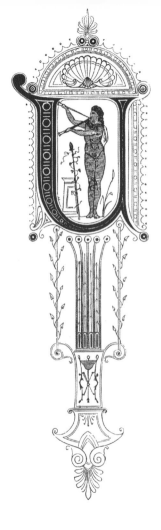

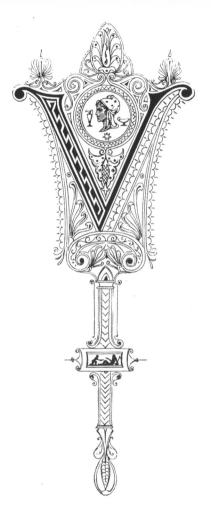

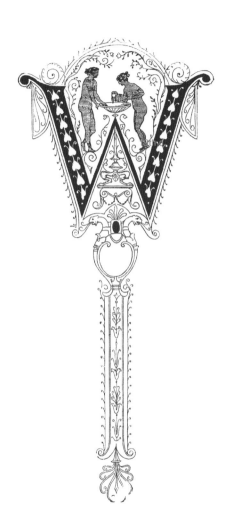

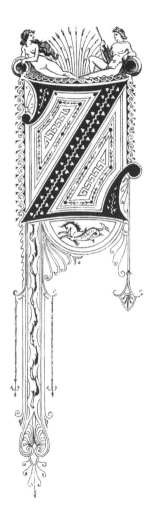

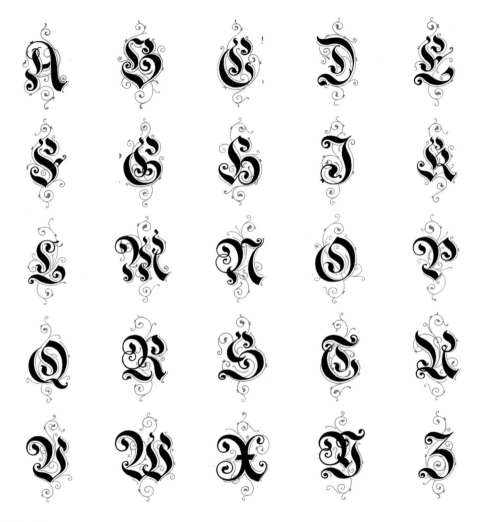

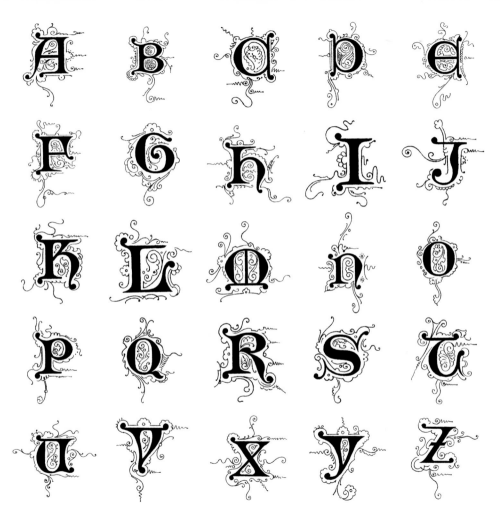

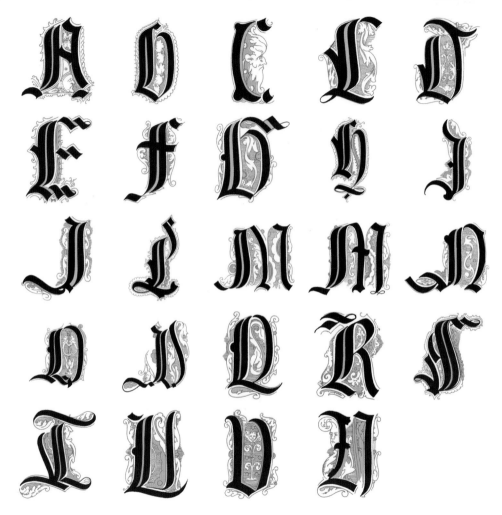

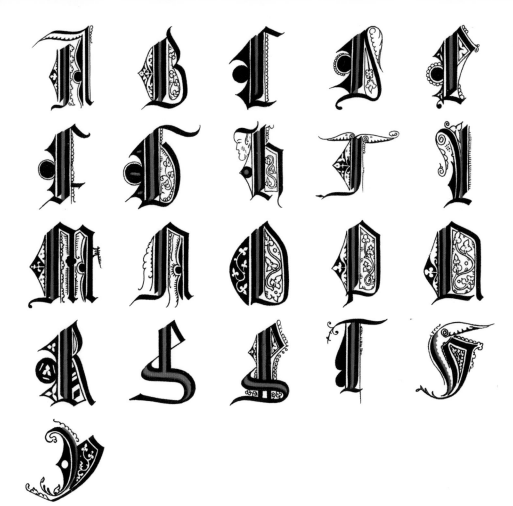

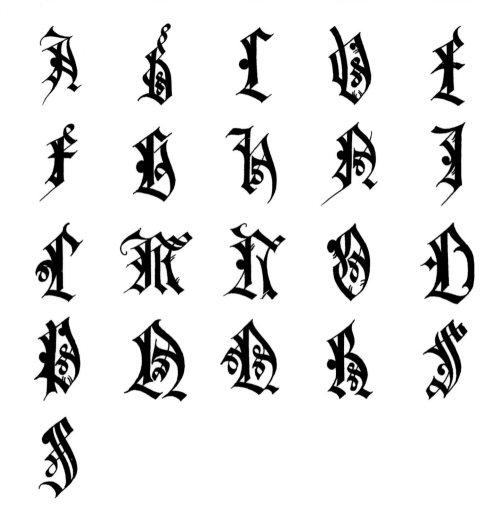

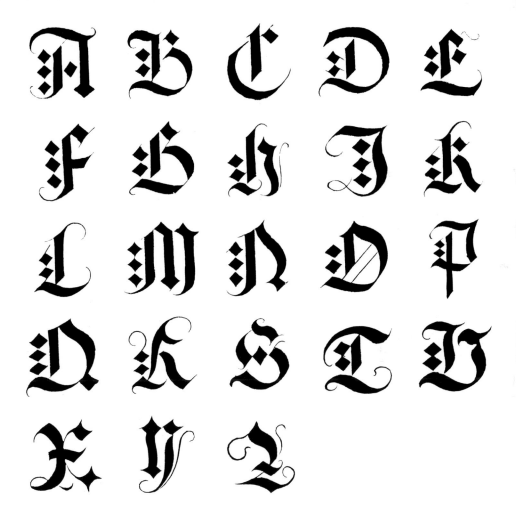

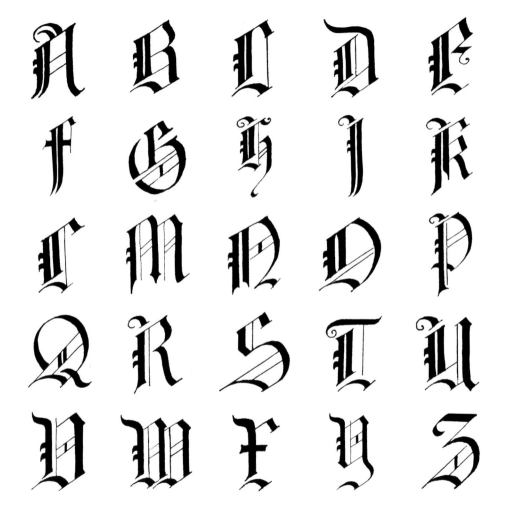

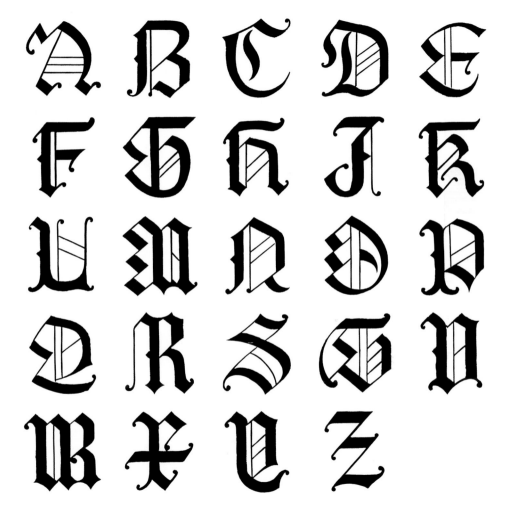

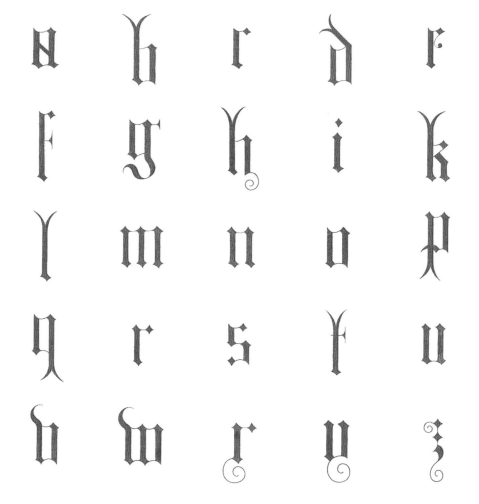

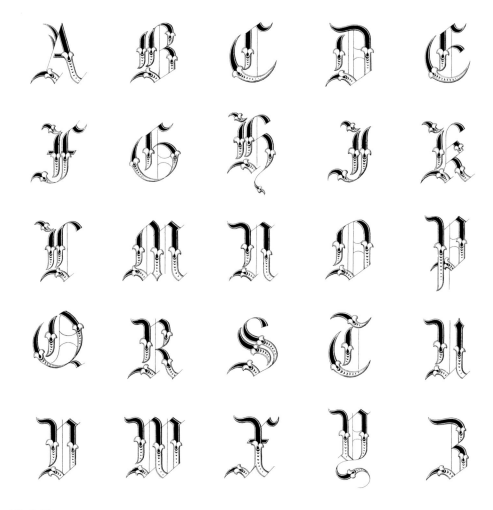

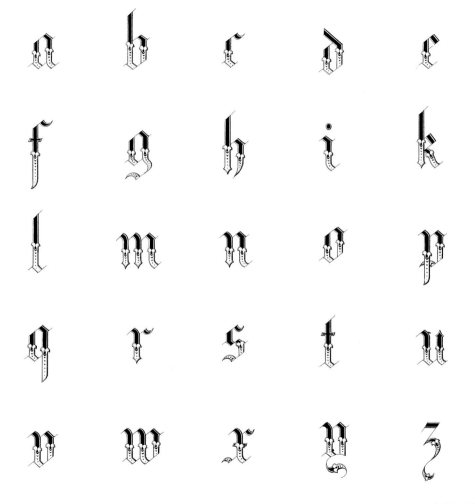

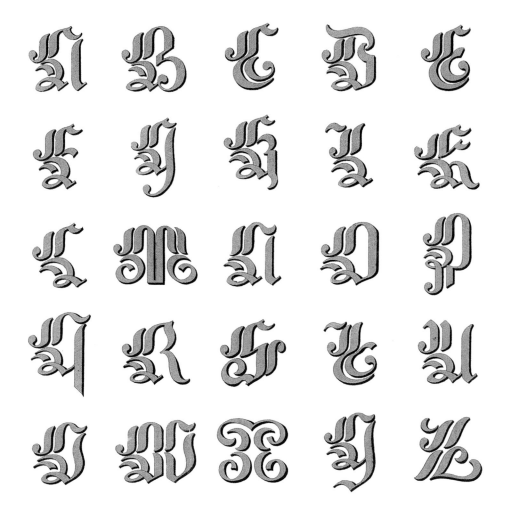

a b c d e

f g h i k

l m n o p

q r s t u

v w x y z

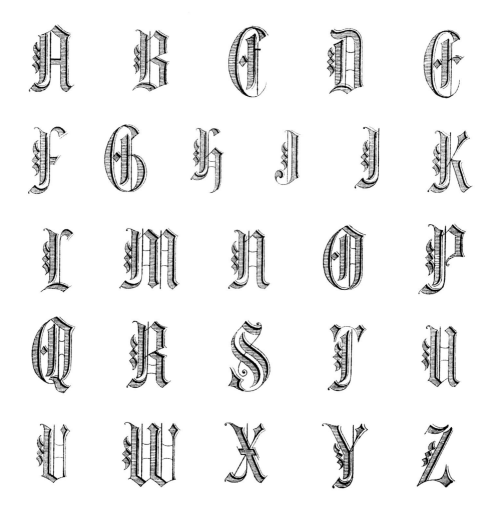

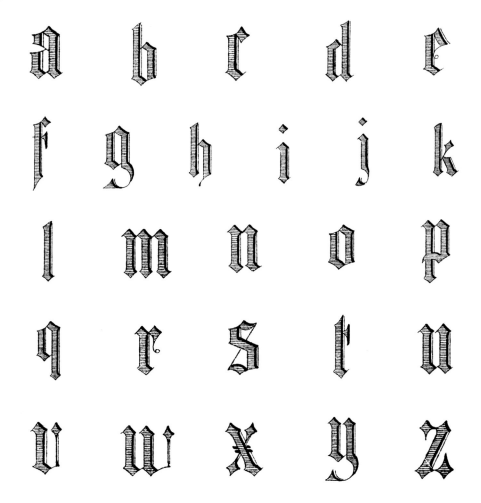

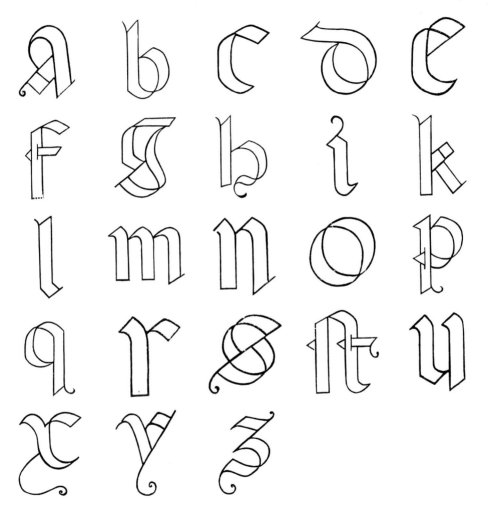

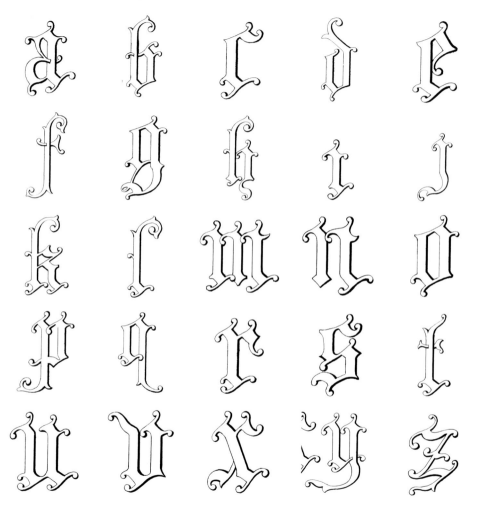

Gothic, Albert Dürer, Germany, 16th c. **125**

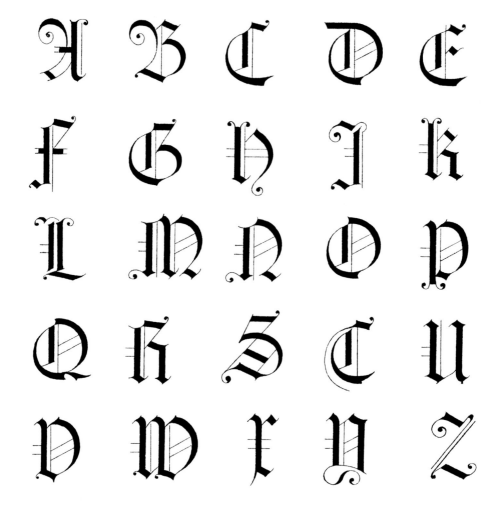

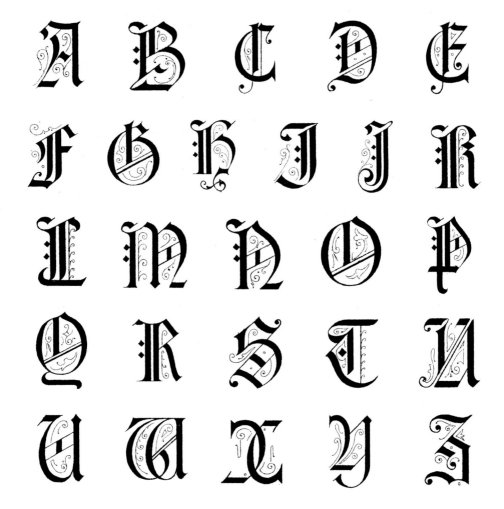

a b r d e
f g h i j k
l m n o p
q r s t u
u w f y z

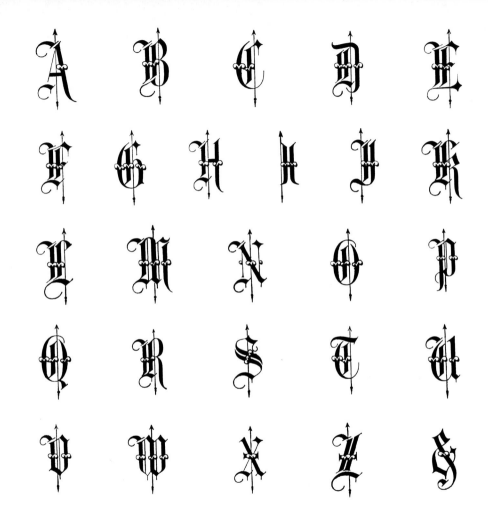

a b c d e

f g h i k

l m n o p

q r s t u

v w x z

A B C D E
F G H I J K
L M N O P
Q R S T U
V W X Y Z

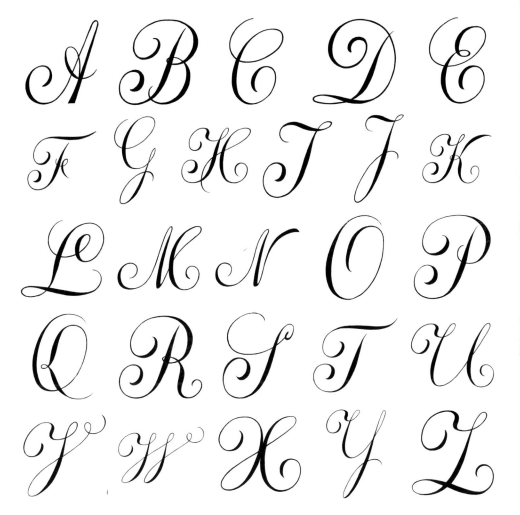

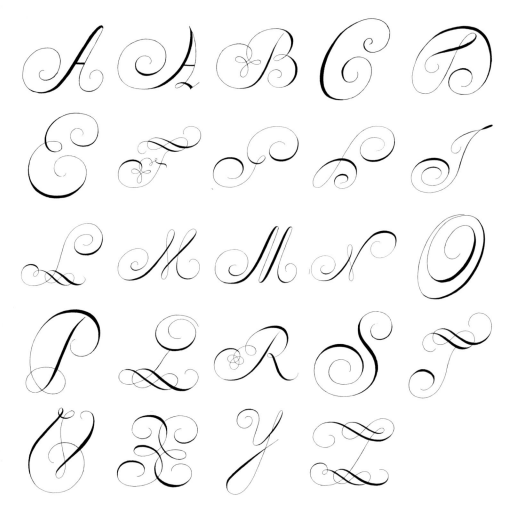

140 Cristophe Weijle, Germany, 18th c.

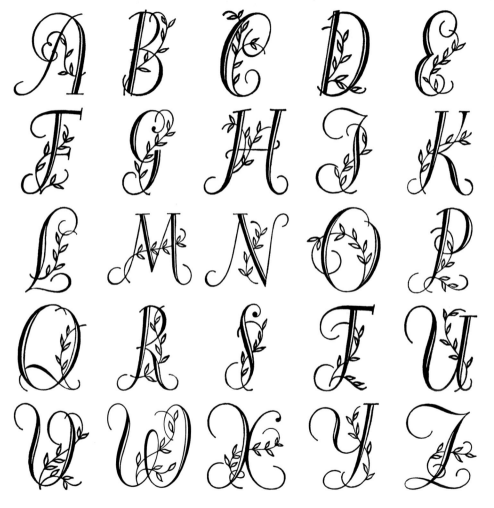

Maria Ballé, Germany, ca. 1920 **143**

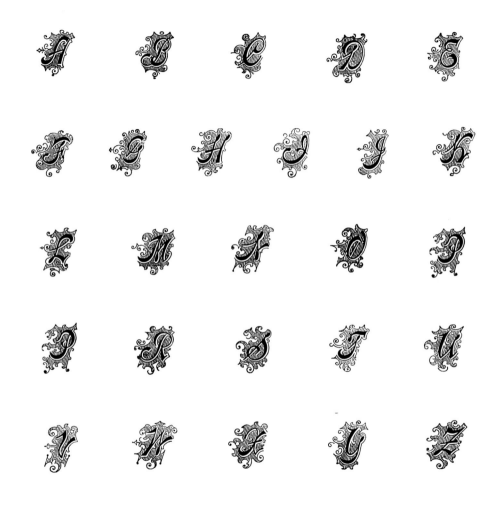

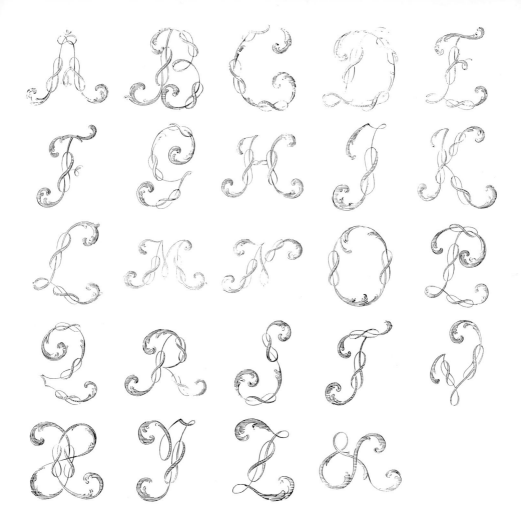

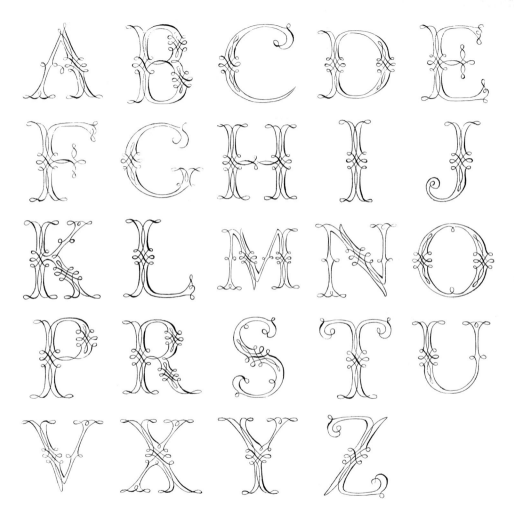

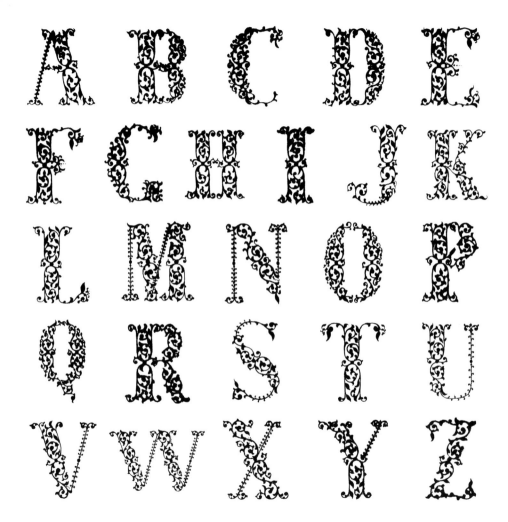

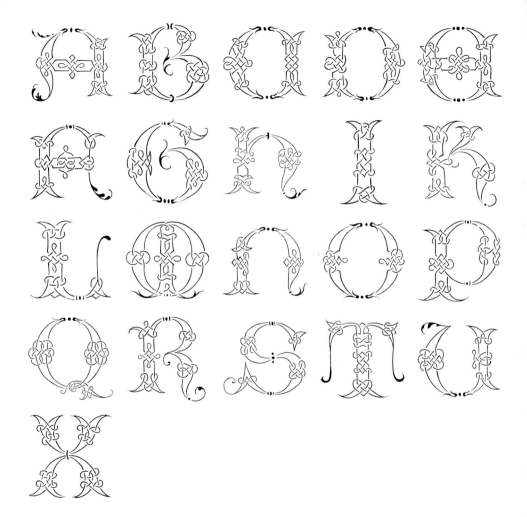

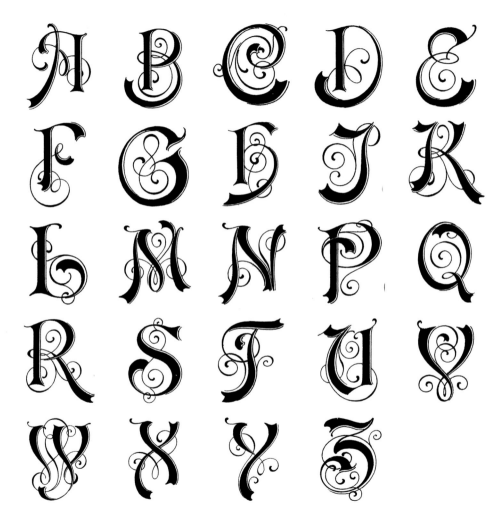

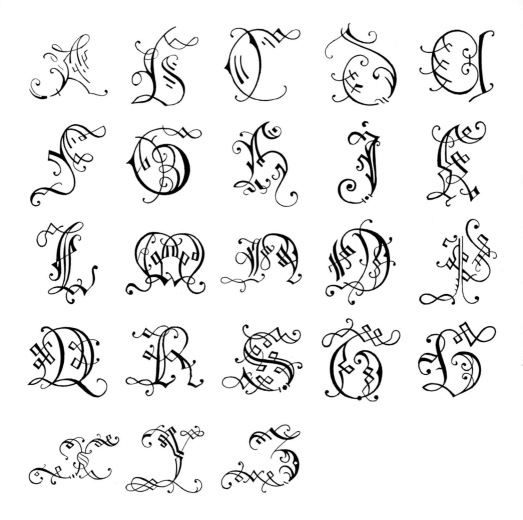

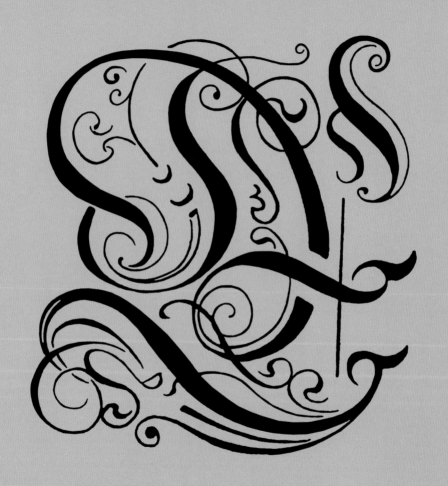

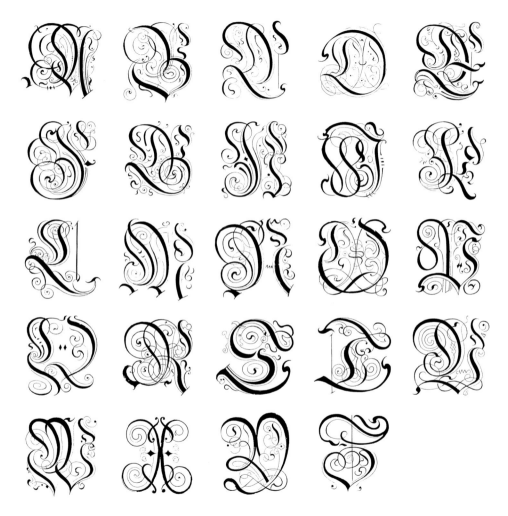

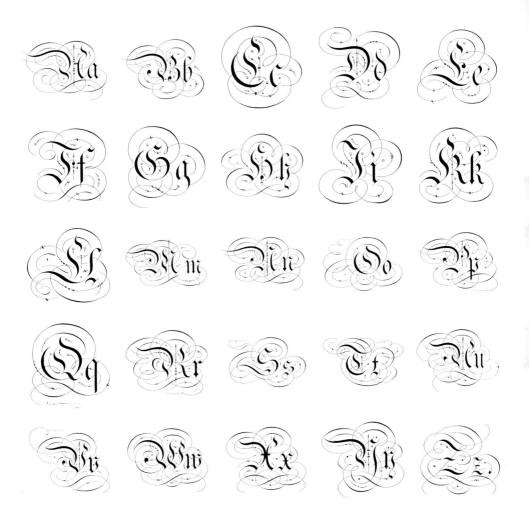

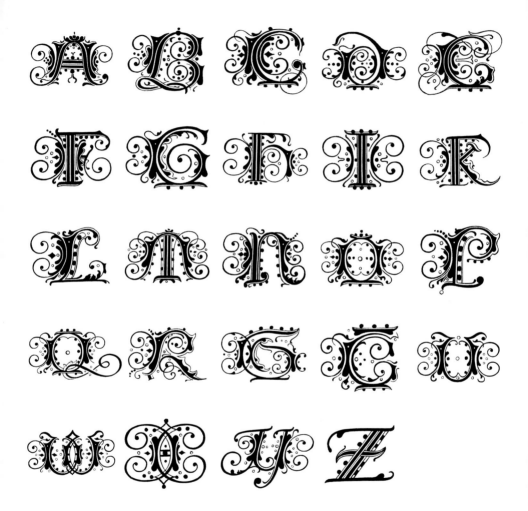

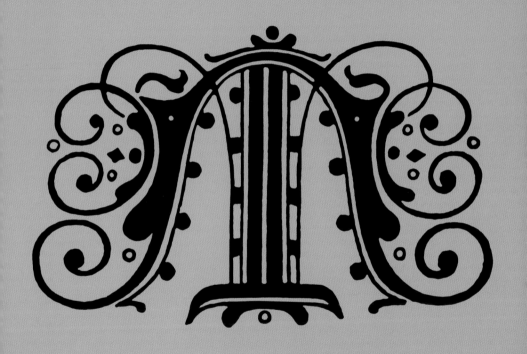

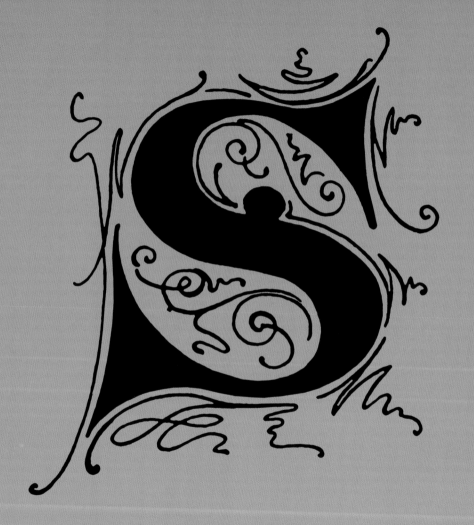

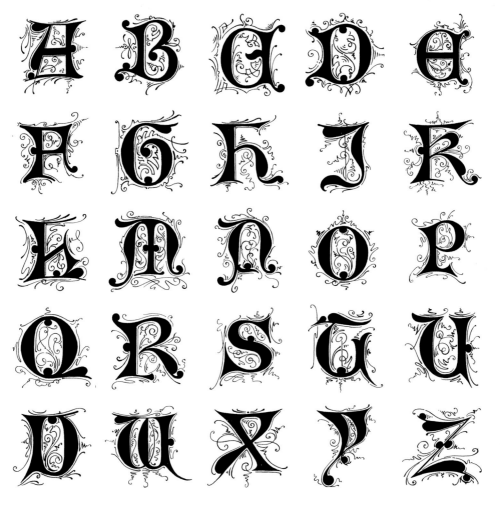

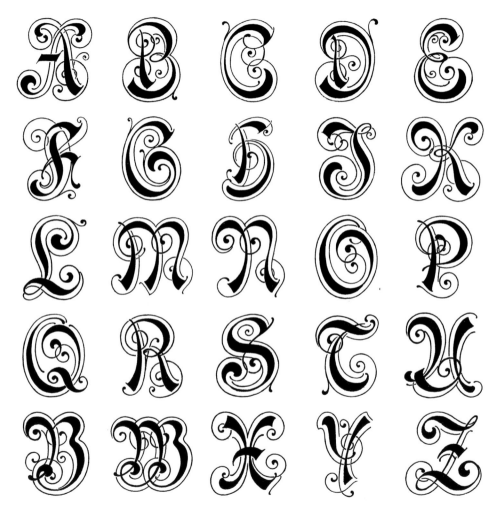

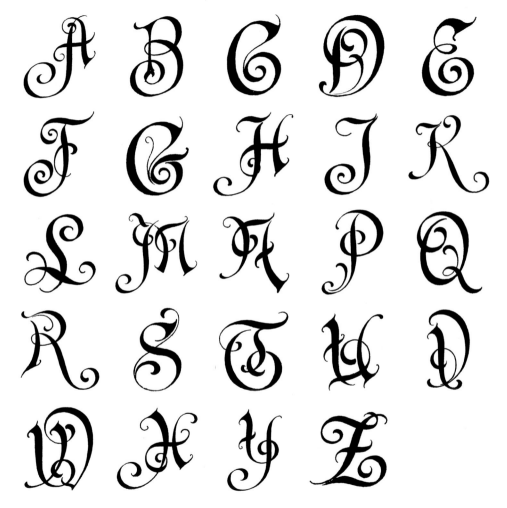

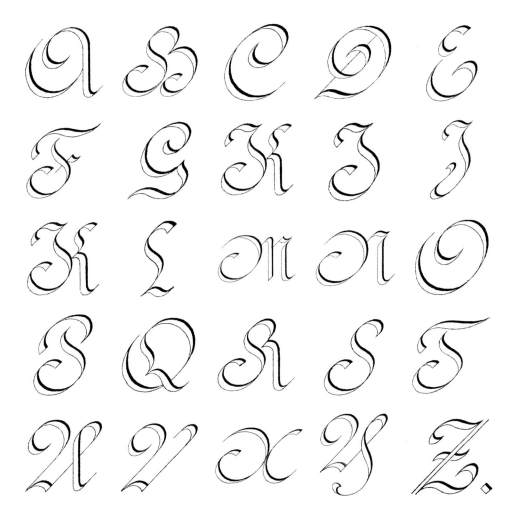

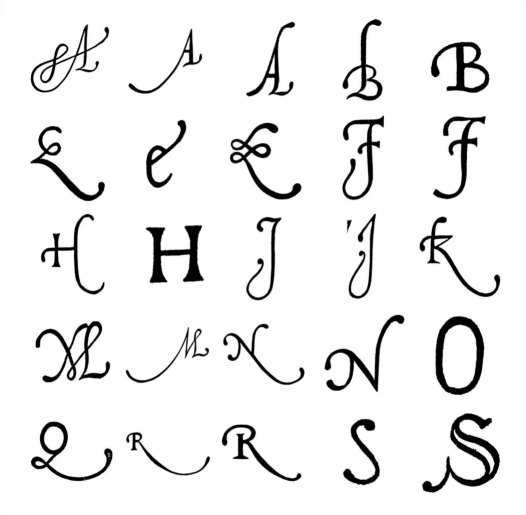

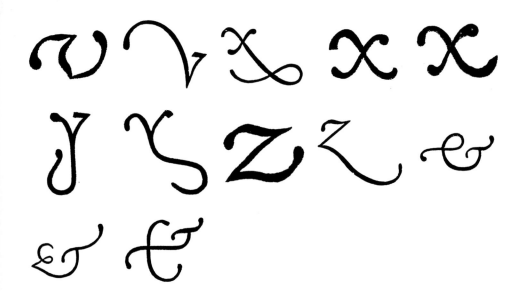

Lewis F. Day, England, 19th c.

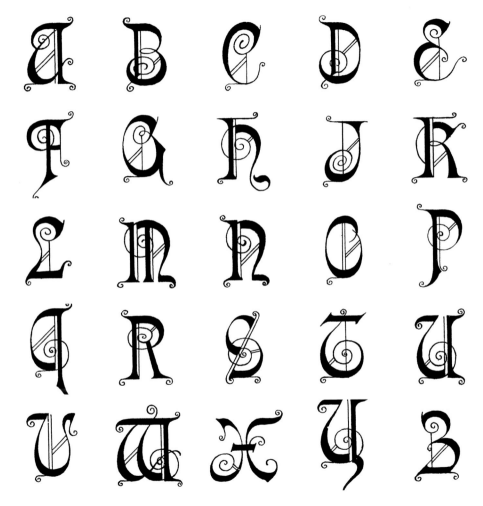

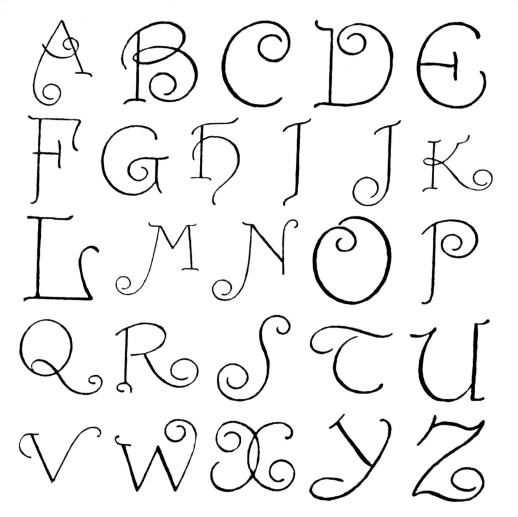

172 England, 19th c.

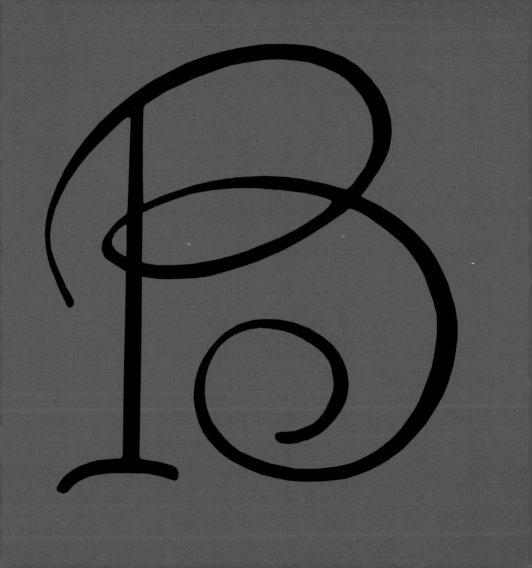

A B C D E F G H I K L M N O P Q R S T V W X Y Z

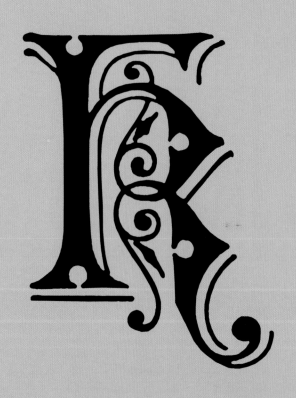

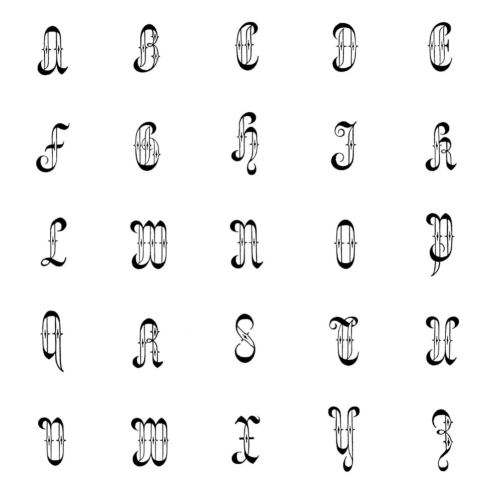

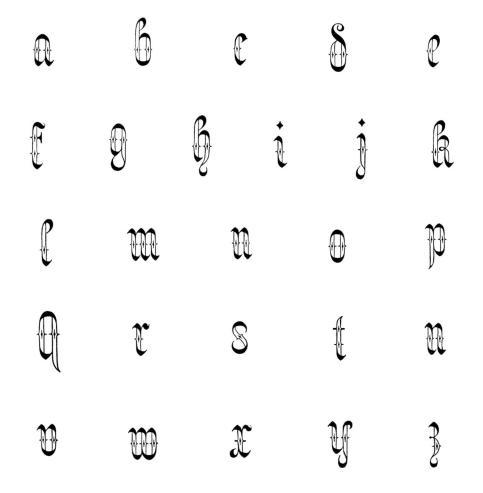

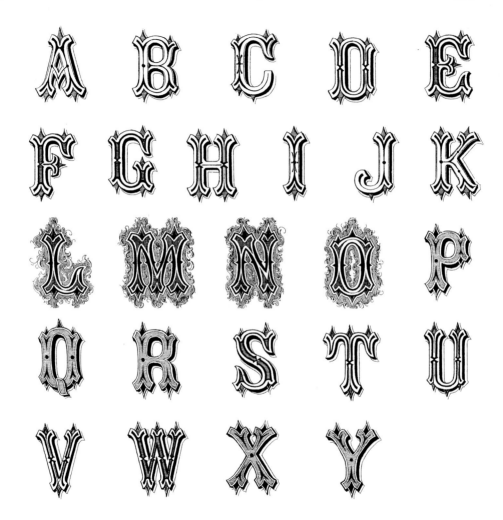

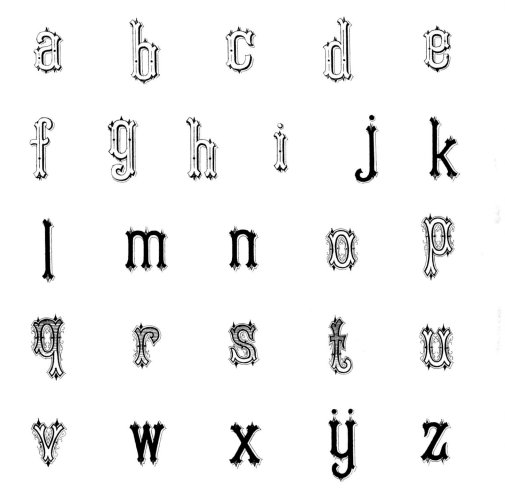

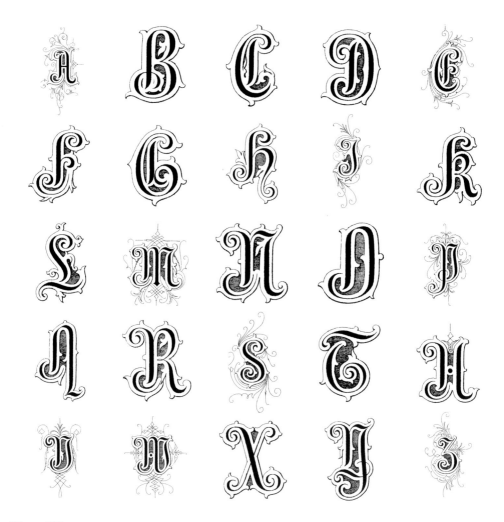

a b c d e

f g h i j k

l m n o p

q r s t u

v w x y z

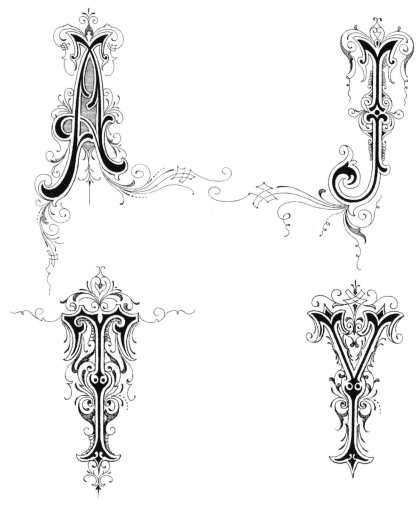

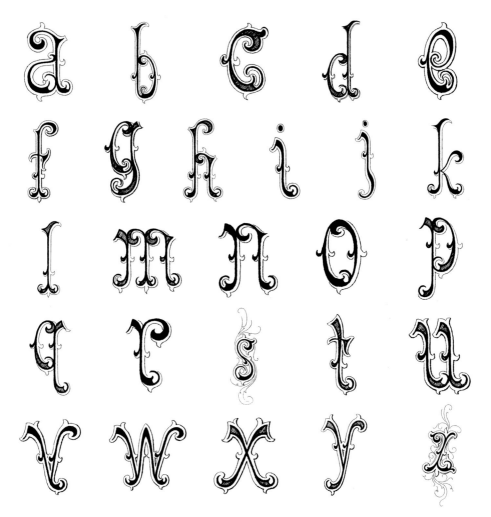

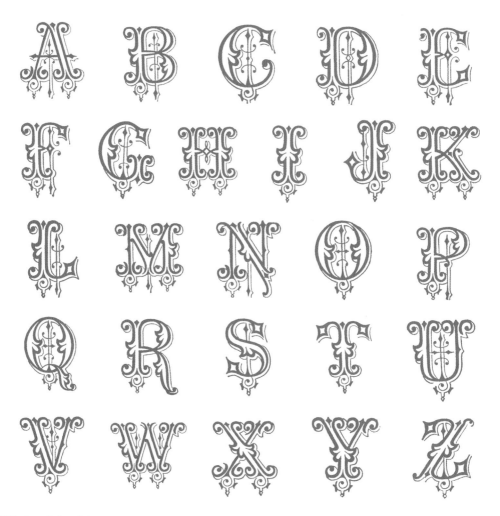

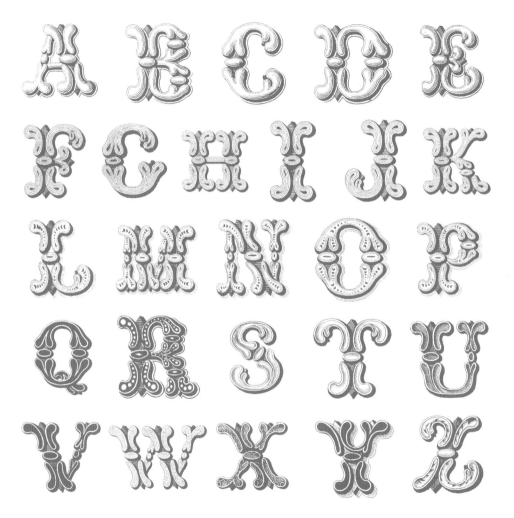

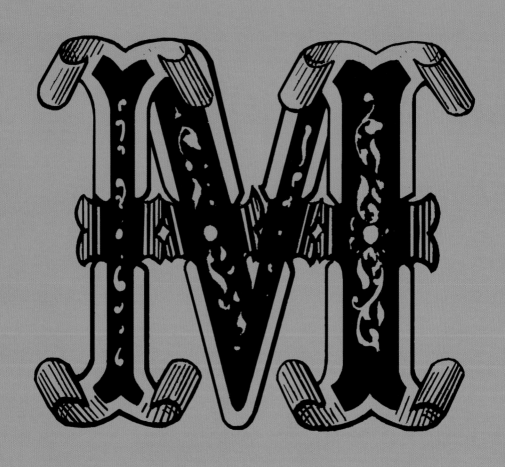

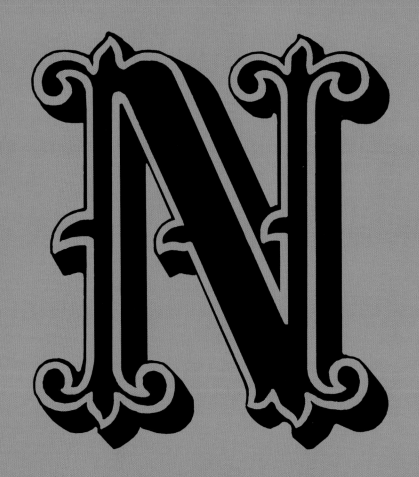

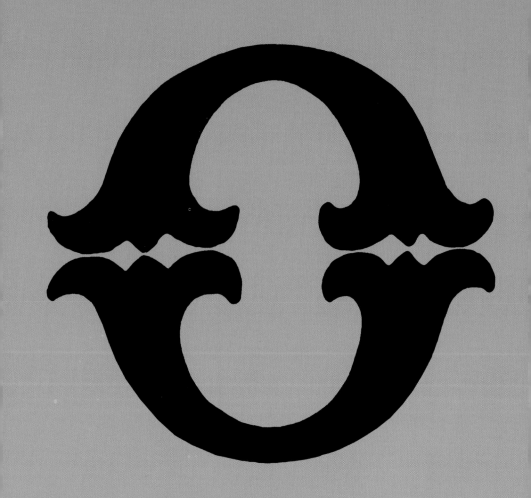

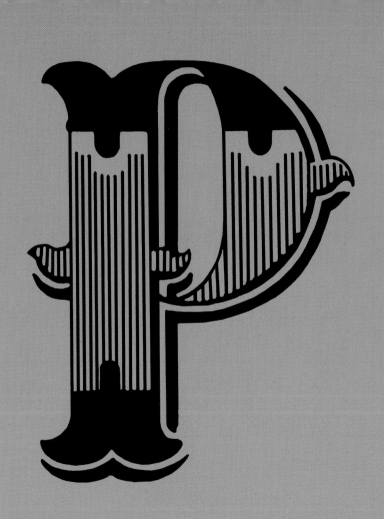

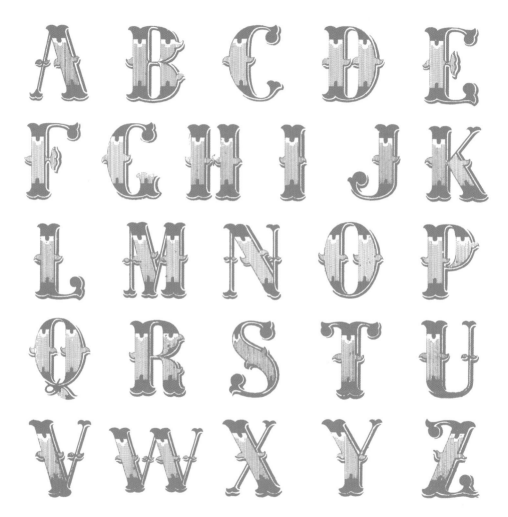

196 France, ca. 1870

ABCDE
FGHIJK
LMNOP
QRSTU
VWXYZ

A B C D E
F G H I J K
L M N O P
Q R S T U
V W X Y Z

a b c d e

f g h i j k

l m n o p

q r s t u

v w x y z

a b c d e
f g h i j
k l m n o
p q r s t
u v x y z

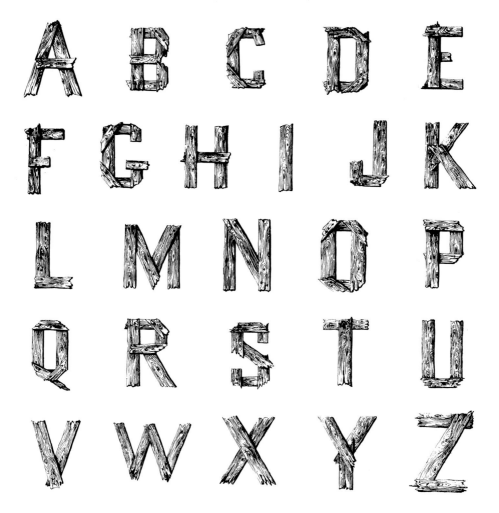

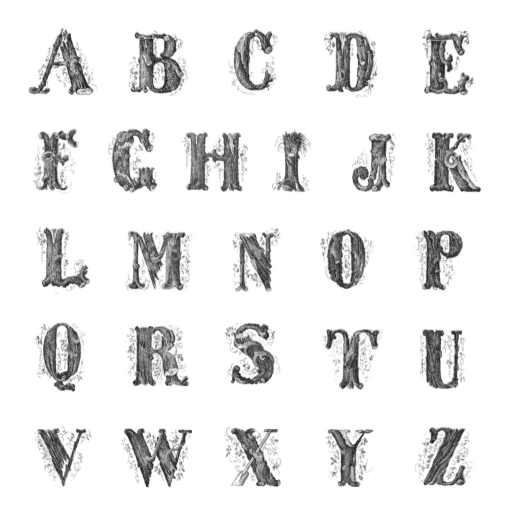

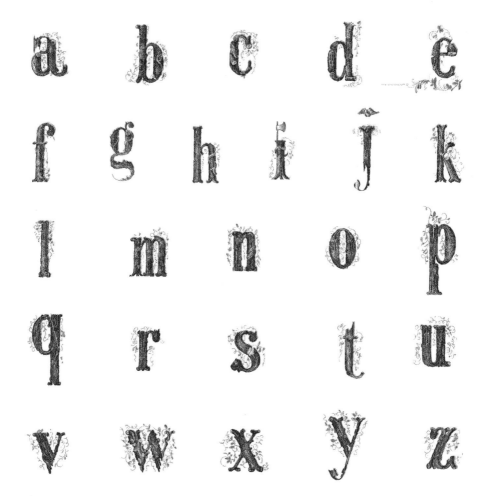

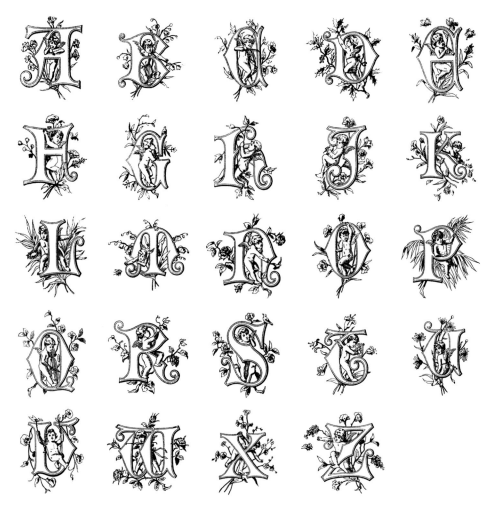

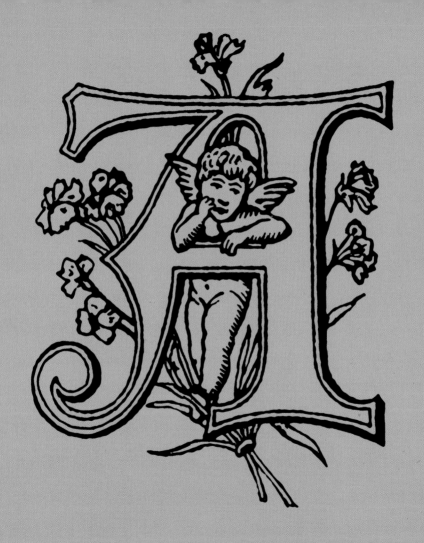

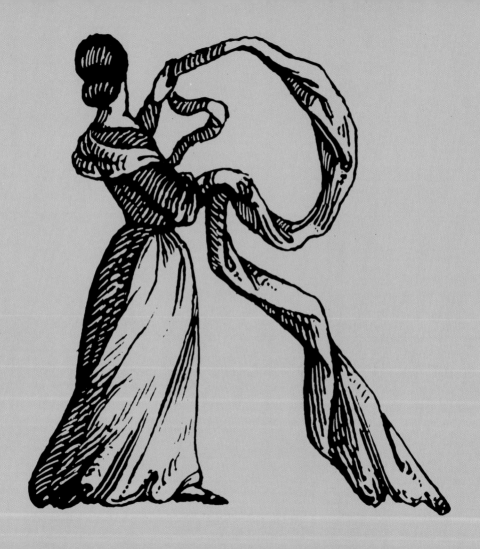

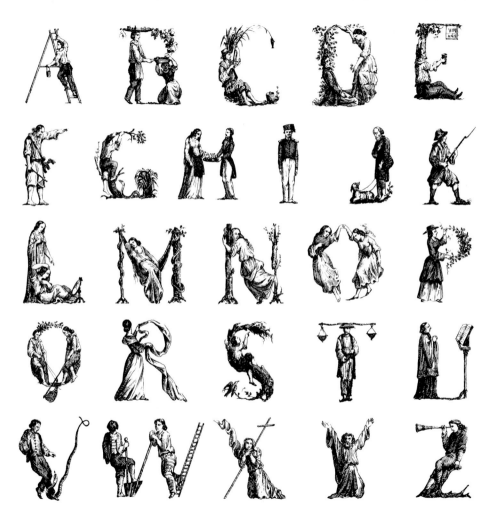

'Silhouette', France, 19th c.

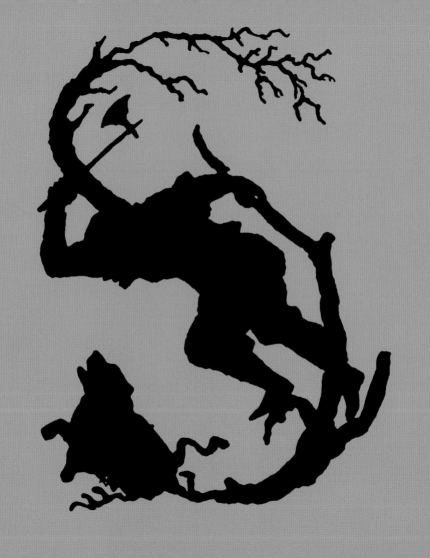

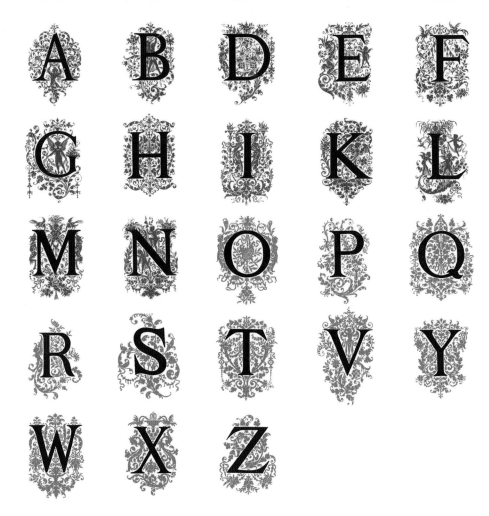

'silhouette'

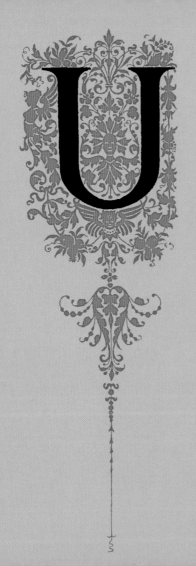
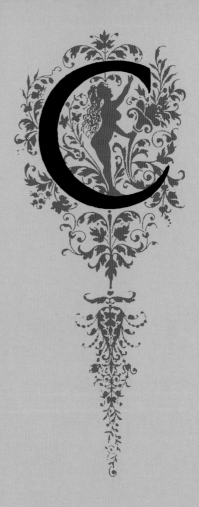

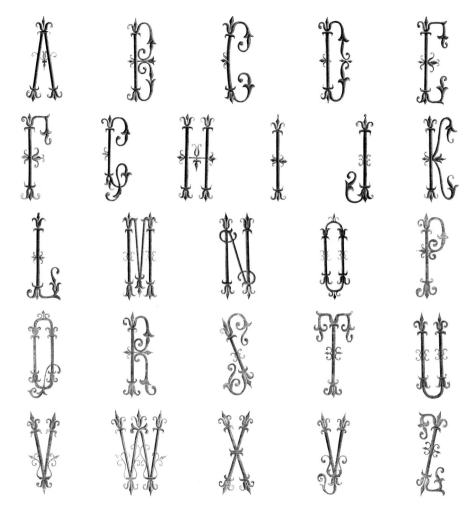

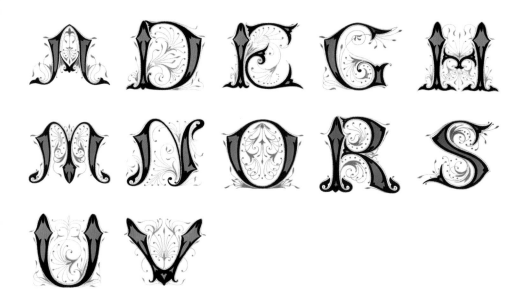

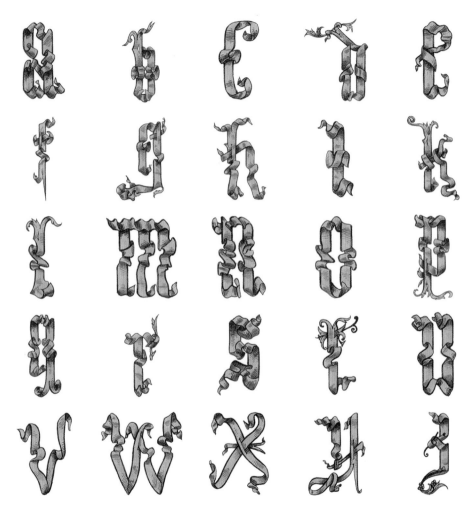

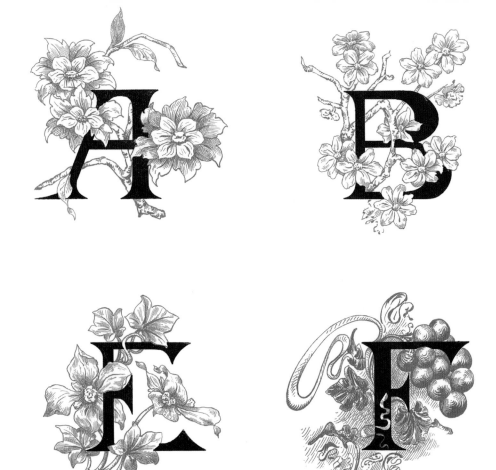

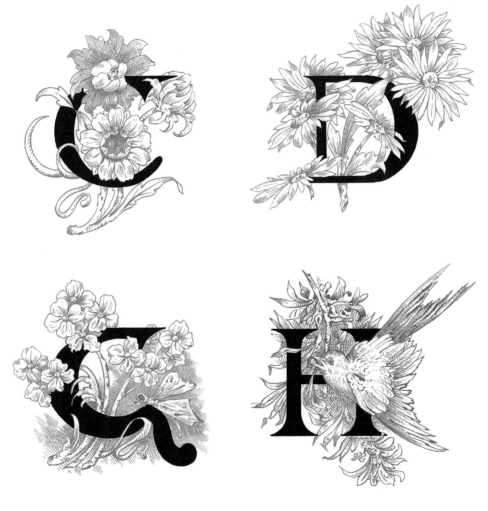

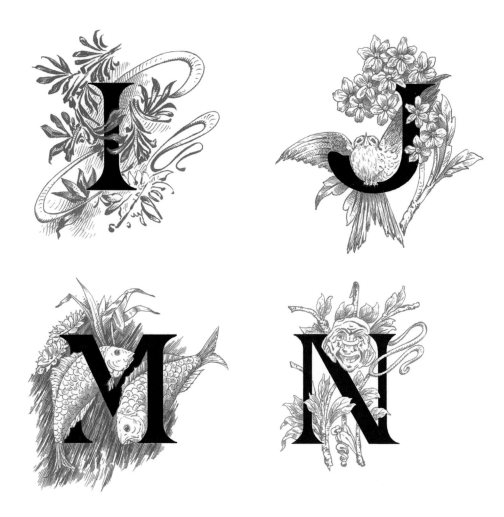

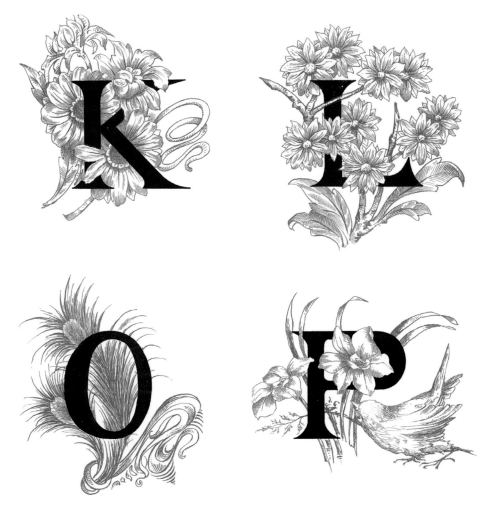

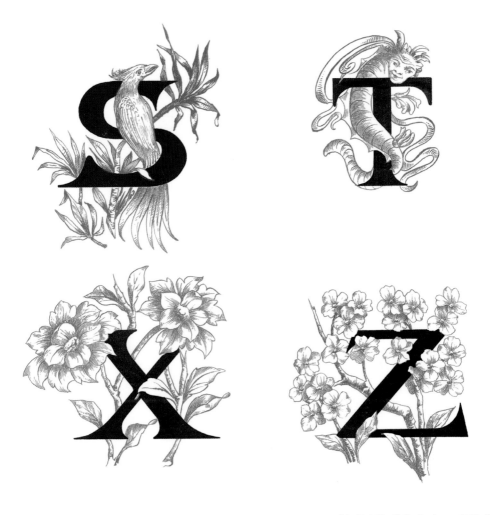

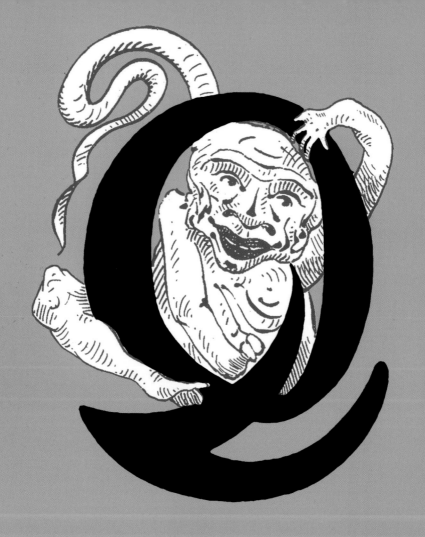

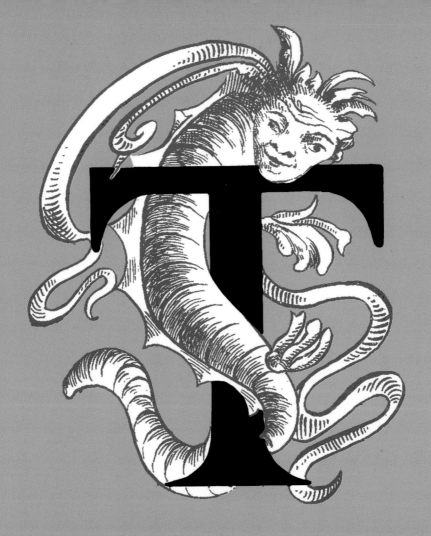

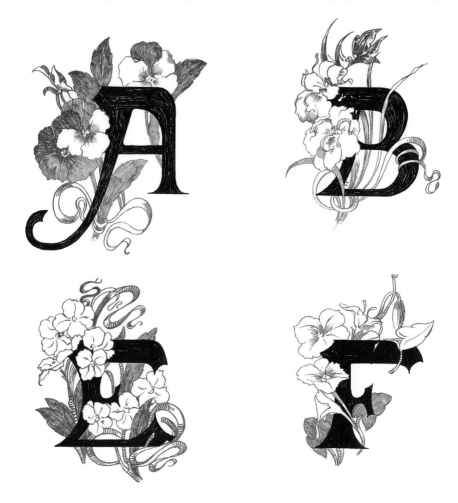

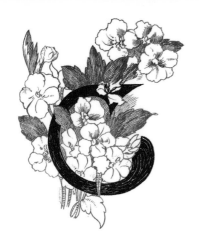

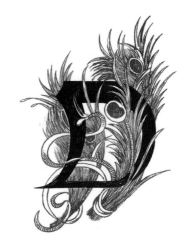

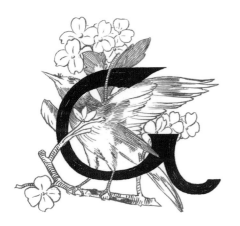

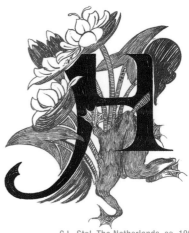

A B C D E
F G H I J K
L M N O P
Q R S T U
V W X Y Z

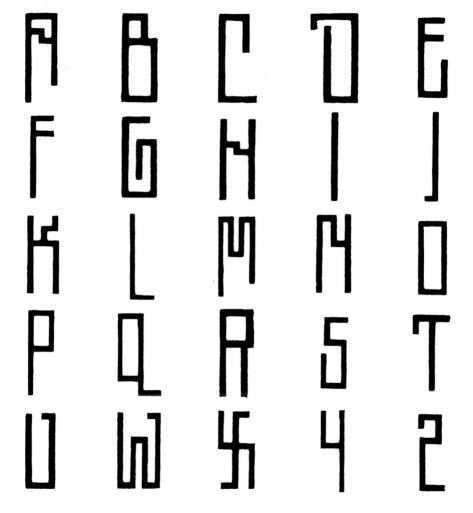

ABCDE
FGHIJK
LMNOP
QRSTU
VWXYZ

244 Rudolph Koch, Germany, ca. 1920

ABCDE
FGHIJK
LMNOP
QRSTU
VWXYZ

Lewis F. Day, England, ca. 1900

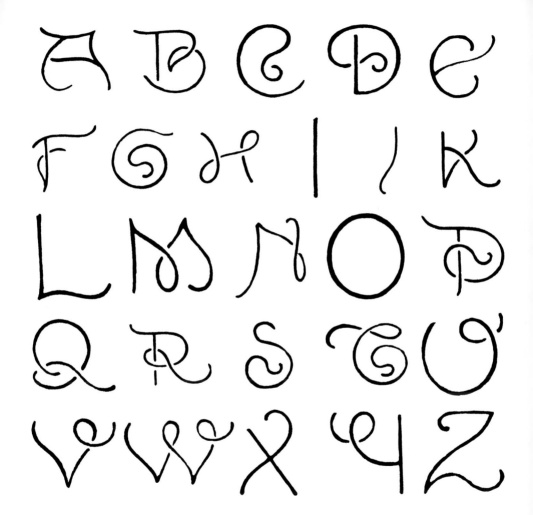

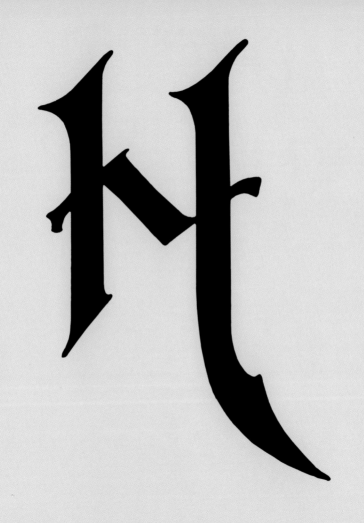

250　Lewis F. Day, England, ca. 1900

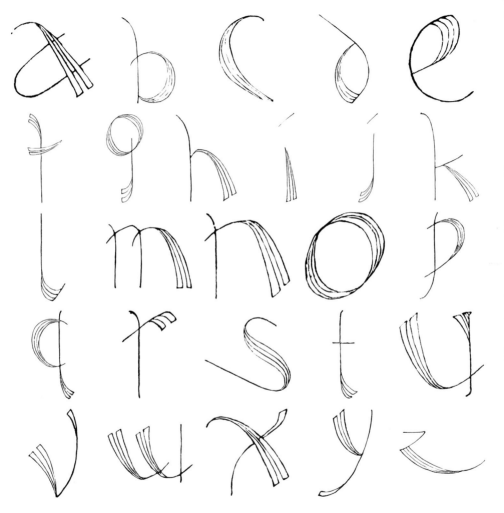

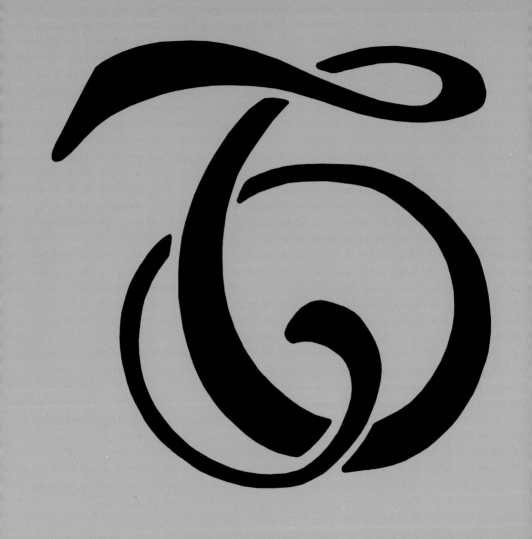

ABCDE
FGHIJK
LmnOP
QRSTU
VwXYZ

'Filigree', The Netherlands, 20th c.

abcde
fghijk
lmnop
qrstu
vwxyz

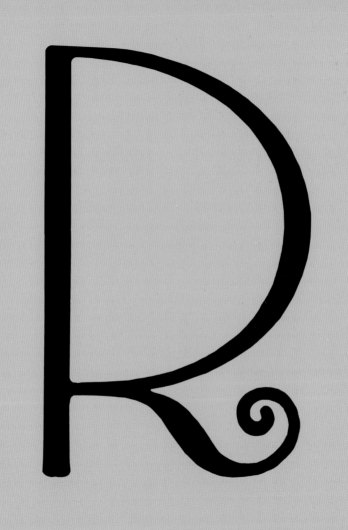

The Netherlands, ca. 1920

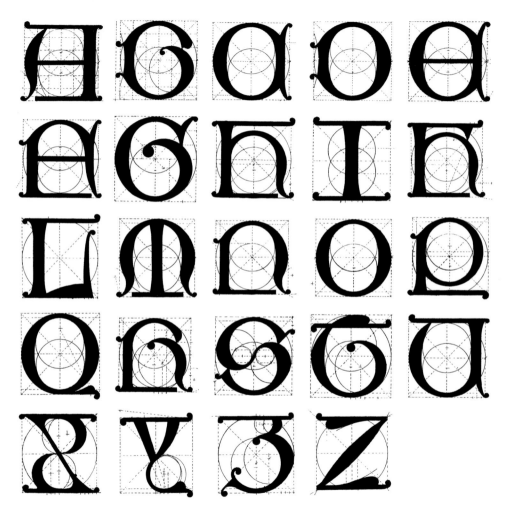

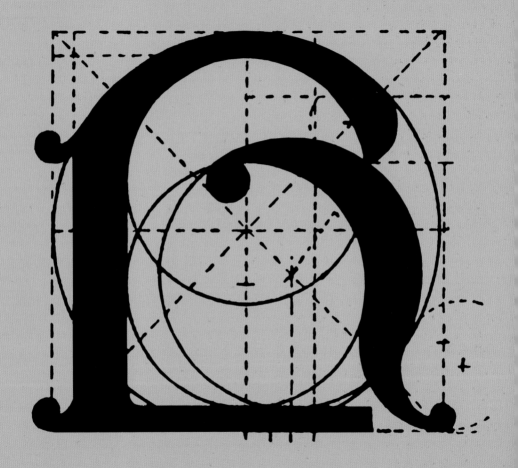

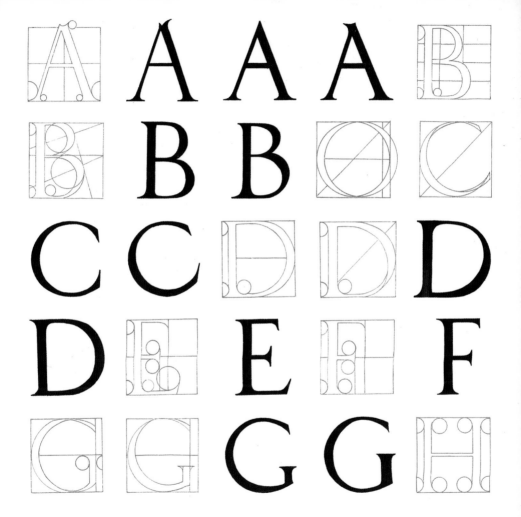

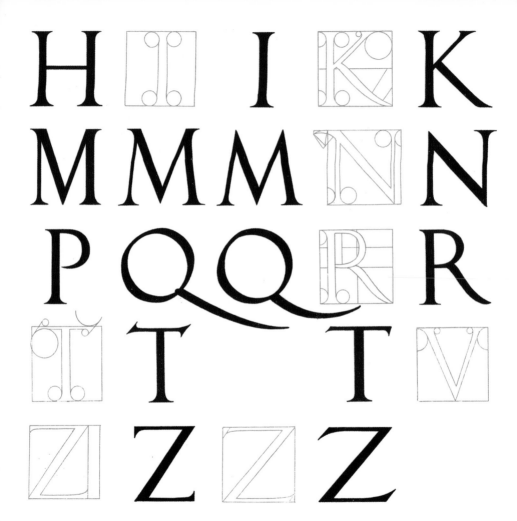

K K L L M M
N N O O P
R R S S S S
V V X X Y Y

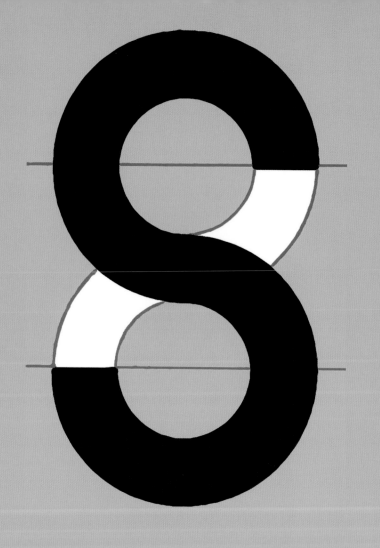

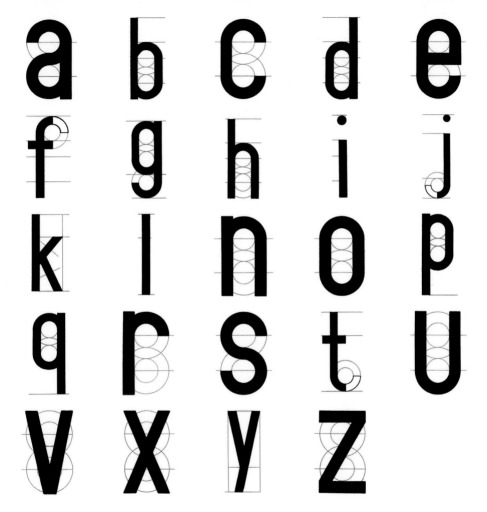

J.B. Heukelom, the Netherlands, ca.1910

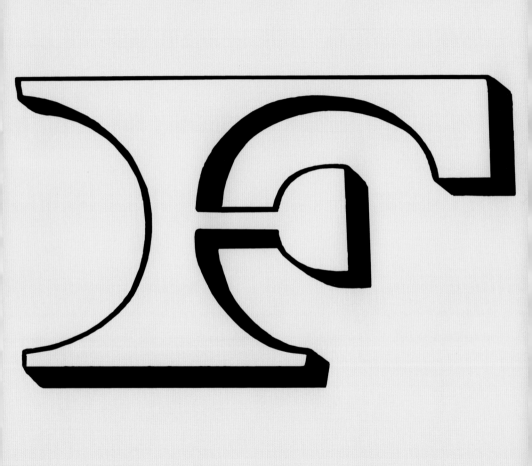

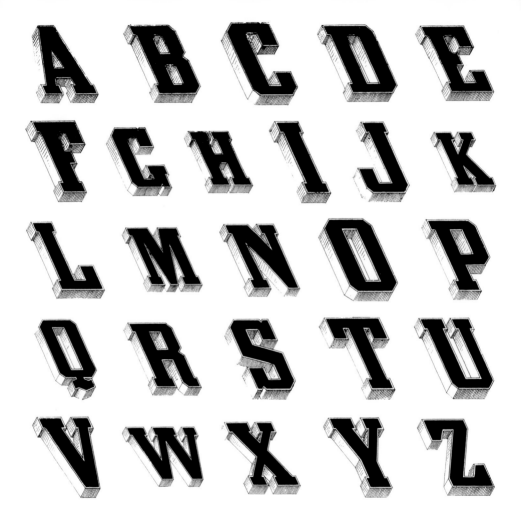

A B C D E

F G H I J K

L M N O P

Q R S T U

V W X Y Z

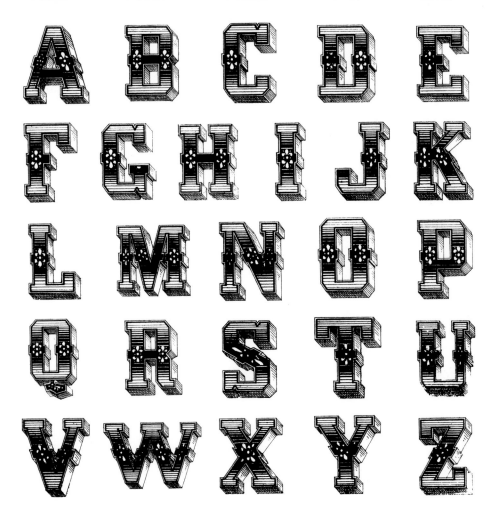

France, 19th c. **275**

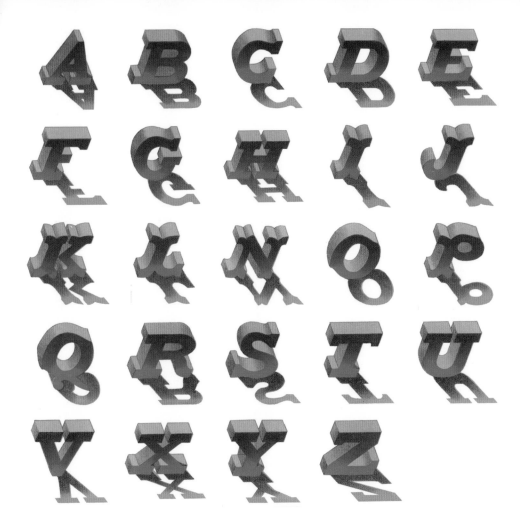

Josef Albers, Germany, ca. 1925